W9-CMG-117

MORNING GLORY ON THE VINE

MORNING GLORY
ON THE VINE

early songs & drawings

JONI MITCHELL

houghton mifflin harcourt boston new york 2019

foreword

In the early 1970s I used to carry a sketchbook around with me everywhere I went. I drew with colored pens. Once when I was sketching my audience in Central Park, they had to drag me onto the stage. After a while I had quite a collection of drawings. The drawings were becoming more important to me than the music at that time.

Christmas rolled around in 1971; all my friends were kind of nouveau riche, so buying Christmas presents was going to be really difficult. I had put the drawings into a ring binder accompanied by hand-written lyrics. Elliot Roberts, my manager, and David Geffen, my agent, took my binder of drawings and lyrics and had a limited edition of books made up, which I called "The Christmas Book," and I was able to give them out for presents that year. People really liked them.

Years ago there was a fire north of Malibu. Henry Lewy, my engineer, and his wife, Nadine, lived there, and I drove over to see them to make sure they were okay. They had packed up a lot of their belongings in bags, and the bags were standing in the hallway of their house. As I walked in, I saw my Christmas book on top of one of the bags. I couldn't believe that was one of the things they were saving.

It's been a long time coming in making this book public, but we're publishing it now. Work is meant to be seen, or heard, as the case may be. It's always exciting to launch your work into the world.

— Joni Mitchell, May 2019

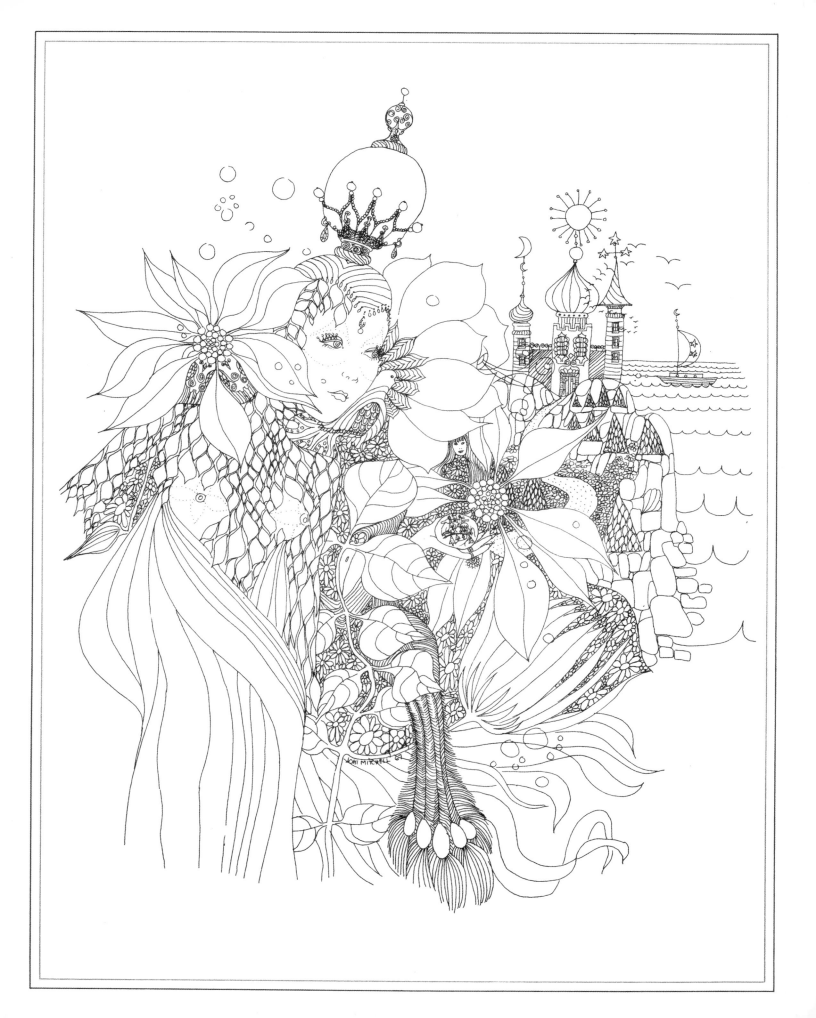

This collection of poems
And songs
And drawings
Is for myself
And for my friends and loves
Who are this book.
The first poem
I wrote under the hairdryer
Preparing a beehive
For a snow-queen contest
After reading "Silver Screen"
And "Movie Mirror."
The beehive was crusted
With silver sparkle dust
And professional spray net
Since I now stood six-foot-two
In my three inch spikes
The coif was a target in the turns
For everyone under five-ten
With short arms –
It developed awful itches I couldn't get at –
But it looked so far out on Sandra Dee ...
Well I knew you can't really knock something
Till you know it – inside and out – all sides
And I find that then, when you understand it
It's hard to knock it
You just feel it – laugh or cry.

Merry Christmas
and
Happy Hollywood

Joni Mitchell

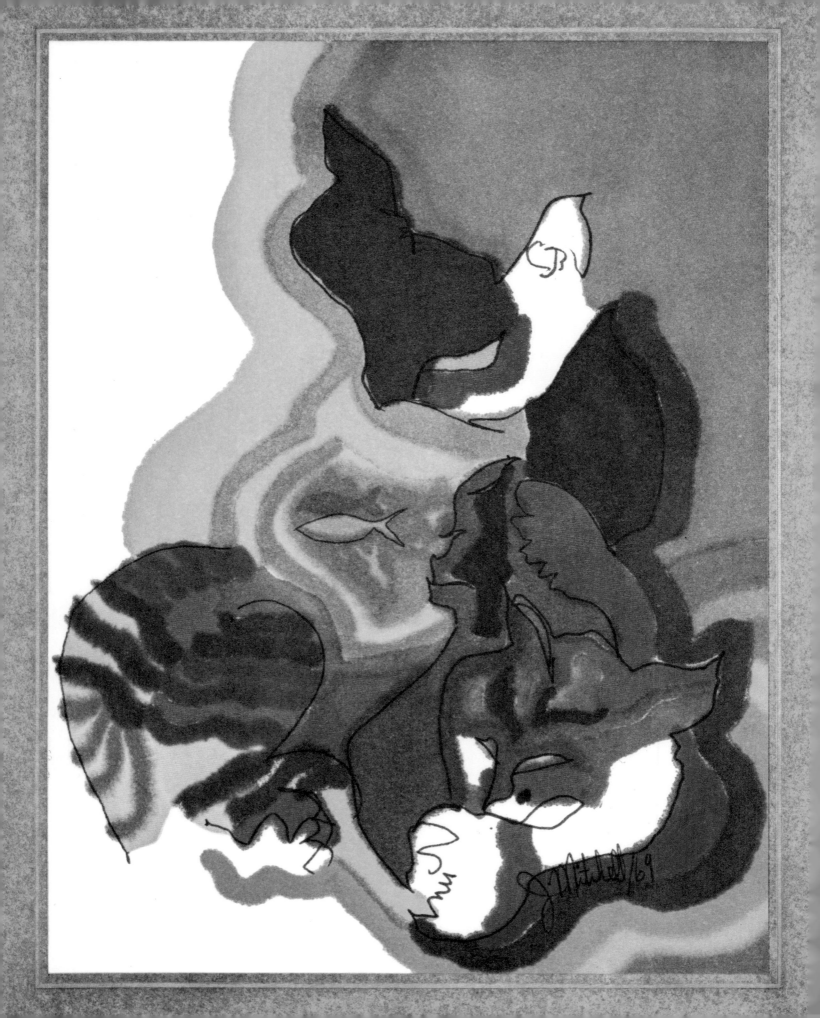

The Fishbowl

The fishbowl is a world reversed
Where fishermen
With hooks that dangle
From the bottom-up
Reel down their catch
On gilded bait.

Pike, pickeral, bass
The common fish
Ogle thru distorting glass
See only glitter,
 glamor,
 gaiety —
Fog up the bowl with lusty breath
Lunge towards the bait and miss
And weep for fortunes lost.

Envy the goldfish — question?
Prisoner of golden scales
His bubbles breaking round the rim
While silly fishes faint for him
Screaming in the isles
Autographed, photographed, cello-wrapped smiles
"Yours forever sincerely"
"Oh Jesus Mary — I think he winked at me!"

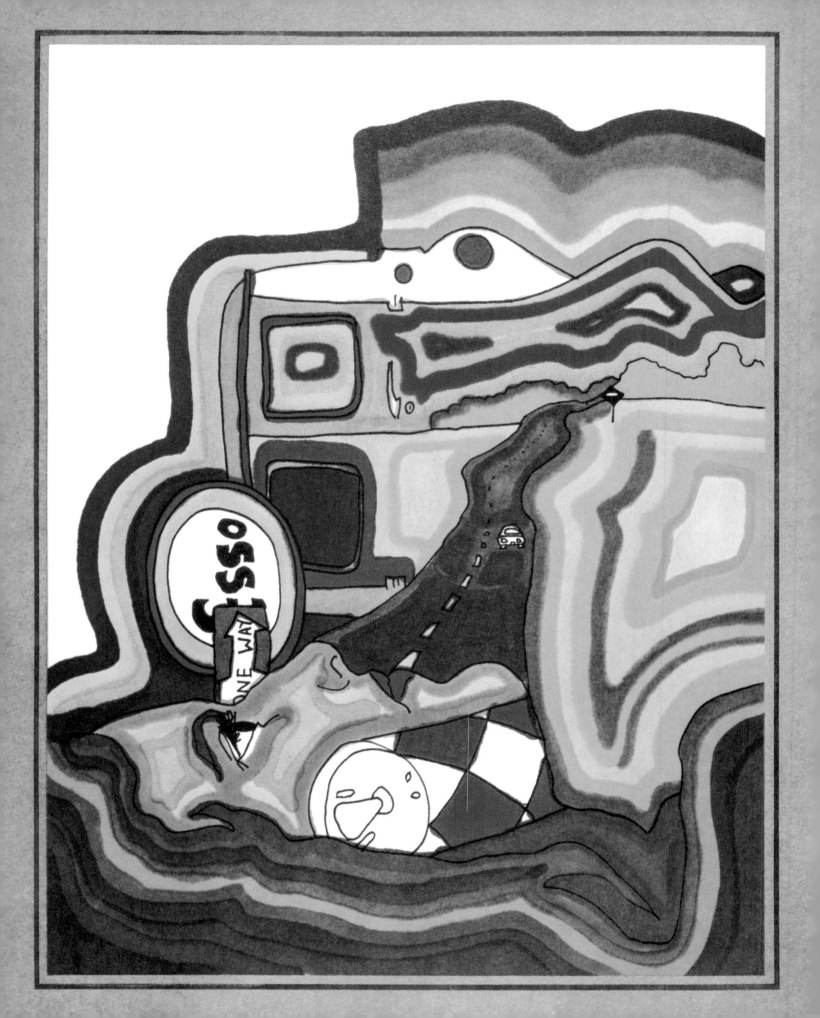

Woodstock

I came upon a child of God
He was walking along the road
And I asked him "Where are you going?"
This he told me
He said "I'm going on down to Yasgurs farm
I'm going to join in a rock 'n' roll band
I'm going to camp out on the land
And try and get my soul free"

 We are stardust
 We are golden
 And we've got to get ourselves
 Back to the garden

"Well can I walk beside you
I have come here to lose the smog
And I feel to be a cog
In something turning
Well maybe it is just the time of year
Or maybe it's the time of man
I don't know who I am
But life is for learning.

 We are stardust
 We are golden
 And we've got to get ourselves
 Back to the garden

By the time we got to Woodstock
We were half a million strong
And everywhere there were songs and celebrations
And I dreamed I saw the bombers
Riding shotgun in the sky
And they were turning
Into butterflies
Above our nation

 We are stardust (billion year old carbon)
 We are golden (caught in the devils bargin)
 And we got to get ourselves
 Back to the garden.

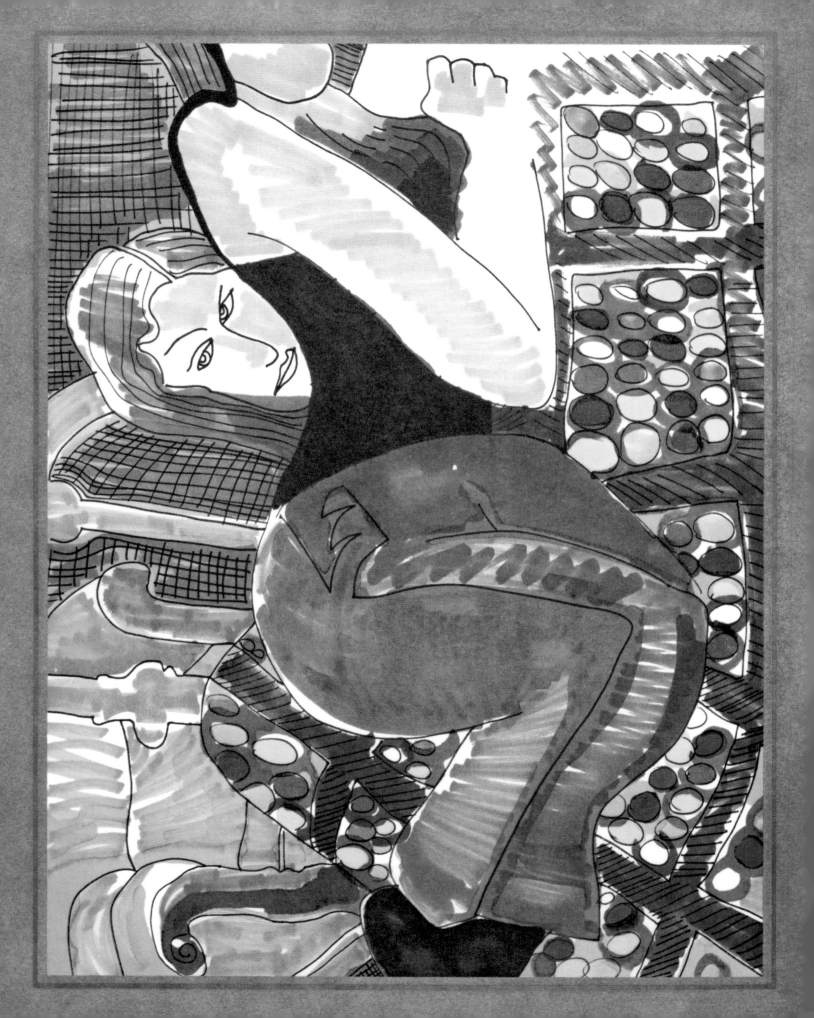

Tempting

"Have some", she said
And the serpant curled
Out of the rubber
'Round the refridgerator door
"Have some more
That's what I made them for."
Calories
Calories
Saliva secretions
Drool
Keep cool
Count the sweet inches on your tongue
The sweet tooth
Has a mainline
Leading to the hips
Clench your lips
"Oh let us both eat some," she said
"Let us grow fat together!"

Munch
Munch.
Just like Adam, Madam.

Cactus Tree

There's a man who's been out sailing
In a decade full of dreams
And he takes her to his schooner
And he treats her like a queen
Bearing beads from California
Pretty amber stones and green –
He has called her from the harbor
He has kissed her with his freedom
He has heard her off to starboard
In the breaking and the breathing
Of the water weeds
While she was somewhere
Being free.

There's a man who's climbed a mountain
And he's calling out her name
And he hopes her heart can hear
Three thousand miles
He calls again
He can think her there beside him
He can miss her just the same
He has missed her in the forest
While he showed her all the flowers
And the branches sang the chorus
As he climbed the scaley tower
Of a forest tree
While she was busy
 Being free.

There's a man you sent a letter
And he's waiting for reply
He has asked her of her travels
Since the day they said goodbye
He writes "Wish you were beside me,
We can make it if we try."
He has seen her at the office
With her name on all his papers
Thru the sharing of the profits
He will find it hard to shake her
From his memory
And she's so busy
 Being free.

There's a lady in the city
And she thinks she loves them all
There's the one who's thinking of her
There's the one who sometimes calls
There's the one who writes her letters
With his facts and figures scrawl
She has brought them to her senses
They have laughed inside her laughter
Now she rallies her defences
For she fears that one will ask her
For eternity
And she's so busy
Being free.

There's a man who sends her medals
He is bleeding from the war
There's a
And a man who owns a store
There's a drummer and a dreamer
And you know
There may be more
She will love them when she sees them
They will lose her if they follow
And she only means to please them
And her heart is full
And hollow
Like a cactus tree
While she's so busy
Being free.

Marcy

Marcy in a coat of flowers
Stops inside a candy store
Reds are sweet
And greens are
Still no letter at her door
So she'll wash her flower curtains
Hang them in the wind to dry
Dust her tables with his shirt
And wave another day, goodbye.

Marcy's faucet needs a plumber
Marcy's sorrow needs a man
Red is autumn
Green is summer
Greens are turning - and the sand
All along the ocean beaches
Stares up empty at the sky
Marcy buys a bag of peaches
Stops a postman passing by

And summer goes
Falls to the sidewalk like string
And brown paper
Winter blows
Up from the river
There's no one to take her
To the sea

Marcy dresses warm
It's snowing
She takes a yellow cab uptown
Red is stop
And green's for going
She sees a show and rides back down
Down along the Hudson River
Past the shipyards in the cold
Still no letter's been delivered
Still the winter days unfold –

　　　Like magazines
　　　Fading in dusty grey attics
　　　And cellars
　　　Make a dream
　　　Dream back to summer
　　　And hear how he tells her
　　　"Wait for me"

Marcy leaves and doesn't tell us
Where or why she moved away
Red is angry
Green is jealous
That was all she had to say
Someone thought they saw her Sunday
Window shopping in the rain
Someone heard she bought a one-way ticket
And went west again.

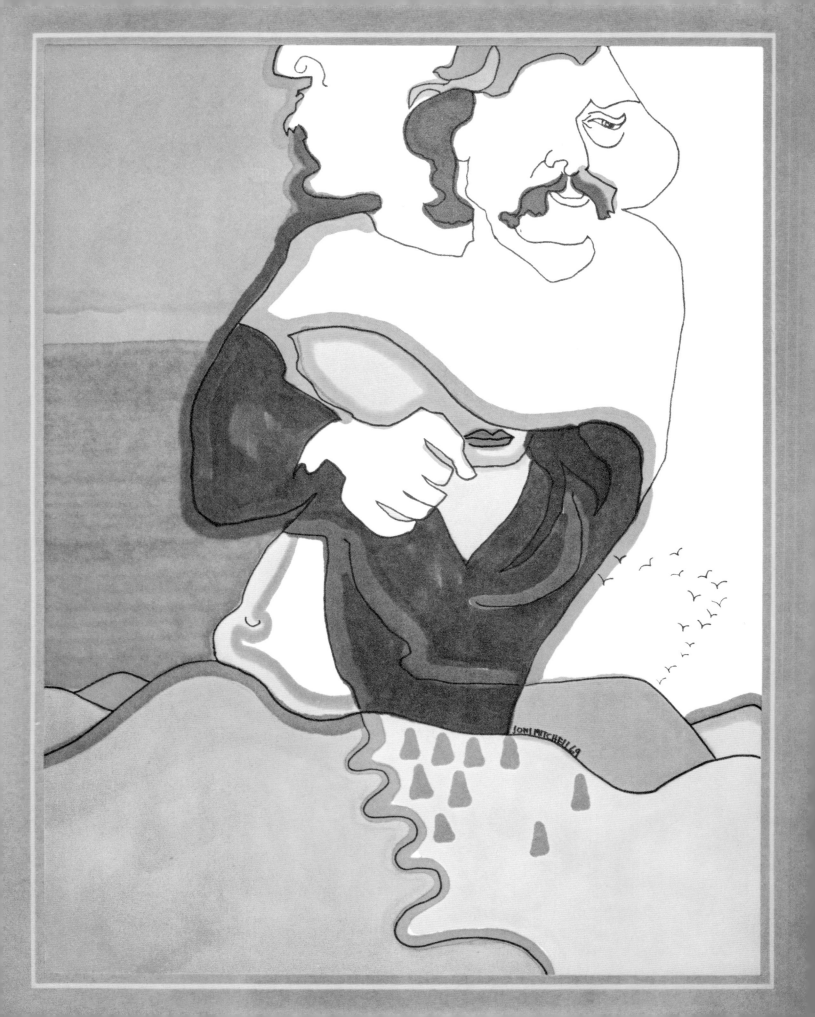

I am a Guitar

I am a guitar
If you pick me up
Having heard beautiful melodies
Played upon me
And to your touch
Comes discord
Disharmony —
Is it then my blame?
He was my virtuoso
Who will play me
Half as well?

Michael

Michael wakes you up with sweets
He takes you up streets
And the rain comes down
Sidewalk markets locked up tight
And umbrellas bright
On a grey background
There's oil on the puddles
In taffeta patterns
That run down the drain
In colored arrangements
That Michael can change
With this stick that he found.

Michael brings you to a park
He sings and it's dark
When the clouds come by
Yellow slickers up on strings
Like puppets on swings
Hanging in the sky
They'll splash home to suppers
In wall papered kitchens
Their mothers will scold
But Michael will hold you
To keep away cold
Till the sidewalks are dry

Michael leads you up the stairs
He needs you to care
And you know you do
Cats come crying to the key
And dry you will be
In a towel or two
There's rain in the window
There's sun in the painting
That shines on the wall
You want to know all
But his mountains have called
So you never do —
Michael from mountains
Go where you will go to
Know that I will know you
Someday, I may know you very well.

Big Yellow Taxi

They paved paradise
And put up a parking lot
A pink hotel, a boutique
And a swinging hot spot
Don't it always seem to go
That you don't know what you got 'till it's gone
They paved paradise
Put up a parking lot.

They took all the trees
And put them in a tree museum
Then they charged all the people
A dollar and a half just to see them
Don't it always seem to go
That you don't know what you got 'till it's gone
They paved paradise
Put up a parking lot.

Hey farmer, farmer
Put away that D.D.T. now
Give me spots on my apples
But leave me the birds and the bees - please.
Don't it always seem to go
That you don't know what you got till it's gone
They paved paradise
Put up a parking lot.

Late last night
I heard the screen door slam
And a big yellow taxi come
And took away my old man
I said, "Don't it always seem to go
That you don't know what you got till it's gone
They paved paradise
Put up a parking lot.

Nathan La Franeer

I hired a cab
To take me from confusion
To the plane
And though we shared a common space
I know I'll never meet again
The driver with his eyebrows furrowed
In the rear-view mirror
I saw his name
Up front - plainly written
Nathan La Franeer

 I asked him would he hurry
 But we crawled the canyons slowly
 Thru the buyers and the sellers
 Thru the burglar bells
 And the wishing wells
 With gangs and girlie shows
 The ghostly garden grows.

The cars and buses bustled
Thru the bedlam of the day
I looked thru window glass at streets
And Nathan grumbled at the grey
I saw an aging cripple
Selling super man balloons
The city grated thru chrome plate
The clock struck loudly
It was noon.

Thru the tunnel
Tiled and turning
Into daylight
Once again I am escaping
Once again goodbye
To symphonies and dirty trees
With parks and plastic clothes
The ghostly garden grows

He asked me for a dollar more
He cursed me to my face
He hated everyone
Who payed to ride
And share his common space
I picked my bags up from the curb
And stumbled to the door
Another man held out his hand
Another hand reached out for more
And I filled it
Full of silver
And I left the fingers counting
And the sky goes on forever
Without meter-maids
And peace parades
You feed it all your woes
The ghostly garden grows.

The Dawntreader

Peridots and periwinkle blue medallions
Gilded galleons spilled across the ocean floor
Treasure somewhere in the sea
And he will find where
Never mind their questions
There's no answer for them
The roll of the harbor wake
The songs that the rigging makes
The taste of the spray
He takes and he learns to give
He aches and he learns to live
He stakes all his silver
On a promise to be free
Mermaids live in colonies
All his seadreams
Come to me.

City satins left at home
I will not need them
I believe him when he tells
Of loving me
Something truthful in the sea
Your lies will find you
"Leave behind your streets" he said
"And come to me."
"Come down from the neon nights"
"Come down from the tourist sights"
"Come down where the rain delights you
You do not hide
"Sunlight will renew your pride"
Skin white by skin golden
Like a promise to be free
Children laughing out to sea
All his seadreams
Come to me.

Seabird I have seen you fly
Above the pilings
I am smiling at your circles in the air
I will come and sit by you
While he lies sleeping
Told your fleet wings
I have brought some dreams to share
A dream that you love someone
A dream that the wars are done
A dream that you tell no one
But the grey sea
They'll say that you're crazy
And a dream of a baby
Like a promise to be free
Children laughing out to sea
All his seadreams
Come to me.

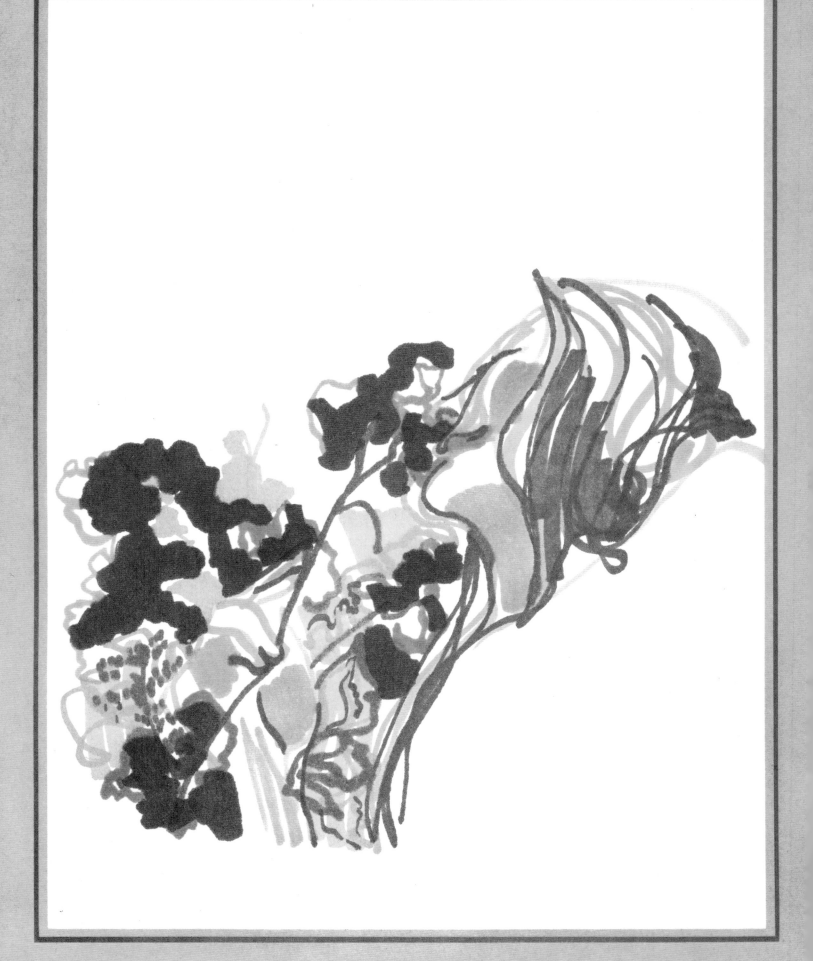

Like Attics

Your armpits smell like attics
They smell like rust and dust
And treasures we entrust to trunks
They smell of musk
Like coloured husks
Of Indian corn
In galvanized water pails
Under the insulation
Close to the rain.

They smell of scorched organdy
And rotting gabardine
And leatherbound books
Swollen like seedpods
Quietlessly sowing loose pages
In mothballs and mildew
And Christmas tree ornaments
Under the red fox collar
With the glass eyes.

The smell has a sting in it
Poking at sneezes
Like spices and strawdust
And pressed flower scrapbooks
With pungence of sages
And potpourri roses
For pages and pages
Thru ages and ages
Yes, the odor is emphatic
Your armpits smell like attics!

Tapwater

Not wishing to appear too fussy
May I have a plain glass glass please?
A china cup will do as well
A brass dipper would have been best
Look, I hate to appear a pest
It is my love of ritual you see
Like wine more merry from a bride's slipper . . .
A little ice
Please and thanks
See the stars cracking inside?
Cold and brilliant . . .
We used to suck on icicles picked off the eves
Mountain springs
Artesian wells
Drew up such drinks as these
But when you bring it
In that thermo-glass
I have to pass
No thanks, I pass
Plastic
Thick
Against my teeth it clicks
Biting
Thick
Against my lips it stings
Naming chemical components
And alternate sponsers
So Cheap
So Pink
So Thick
It makes me think
Of cupie dolls
Wet nail polish
And chewing on rat-tail combs.
It is a drag to drink.

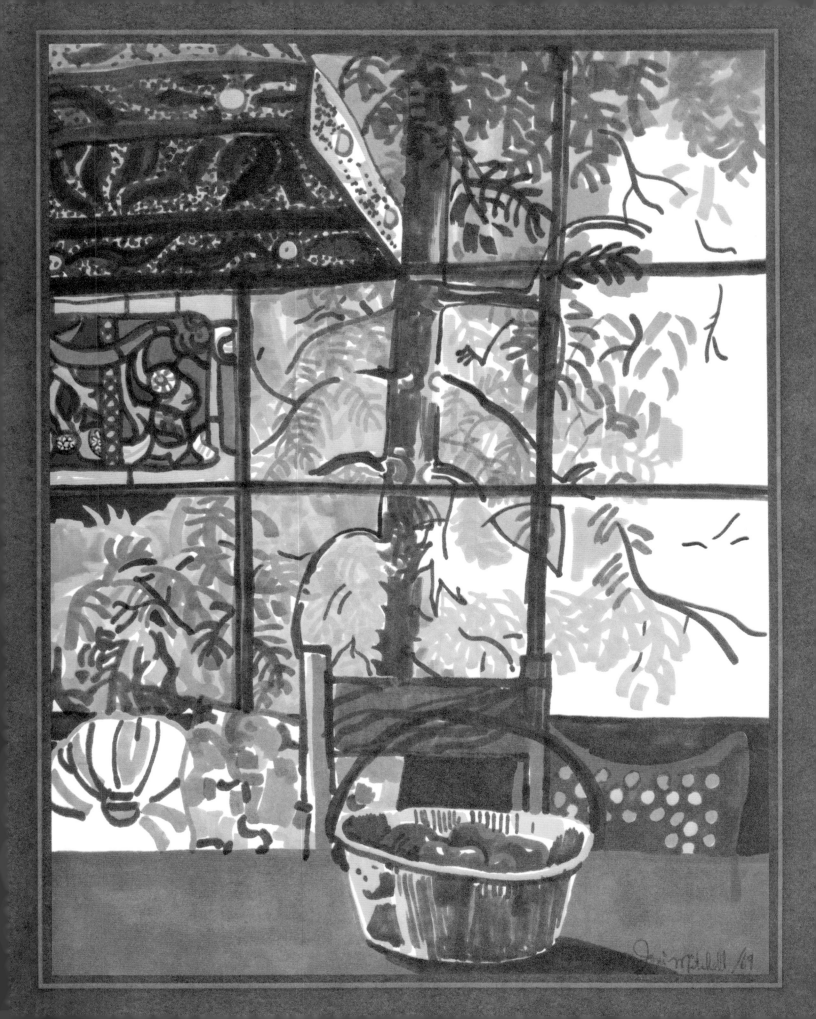

Morning Climbs Sunny

Morning climbs sunny
Thru leaves
It winds the glory vines
And colored glass glints
Ruby tints
Hints of every hue –
Green, gold, purple, blue –
Splinter
Speckled spots of light
Tree shadows shaking
Shifting
Stretching
Reaching() for the kitchen
Knock
Knock
Knock
Knock
The laundryman with clean parcels
In green paper
Comes
Goes
I put away clothes
Towels and sheets
Today I am neat.

Down at the duck pond
Lives a snake
I'm dreaming of childhood lakes
Trails and tents
When the sweet chirping gets bent
Shrill in each bill
As up the street
Come three red trucks
Sirens
Pounding
Headaches

Rounding corners
Sounding
Sounding
Sounding
Dogs howl
Harmonies
Barbershop —
The tenor gets enthusiastic
Yelps in long elastic loops
Scoops —
Flat —
The cat
Ears up
Scowls
Prowls like the critic in the lobby
Till the last foul wail
The siren sound
Is a past pain
Like memory of a migraine.

The rent repaired
I hear the air
Leaf rustle
Chime tinkle
Car swoosh
Bird chipper
Squirrel chatter
Flaming red sun fur
Bumping along a high line
Tea kettle rocking
In a soft high whine
The morning settles
And time unfolds
Ever changing its design.

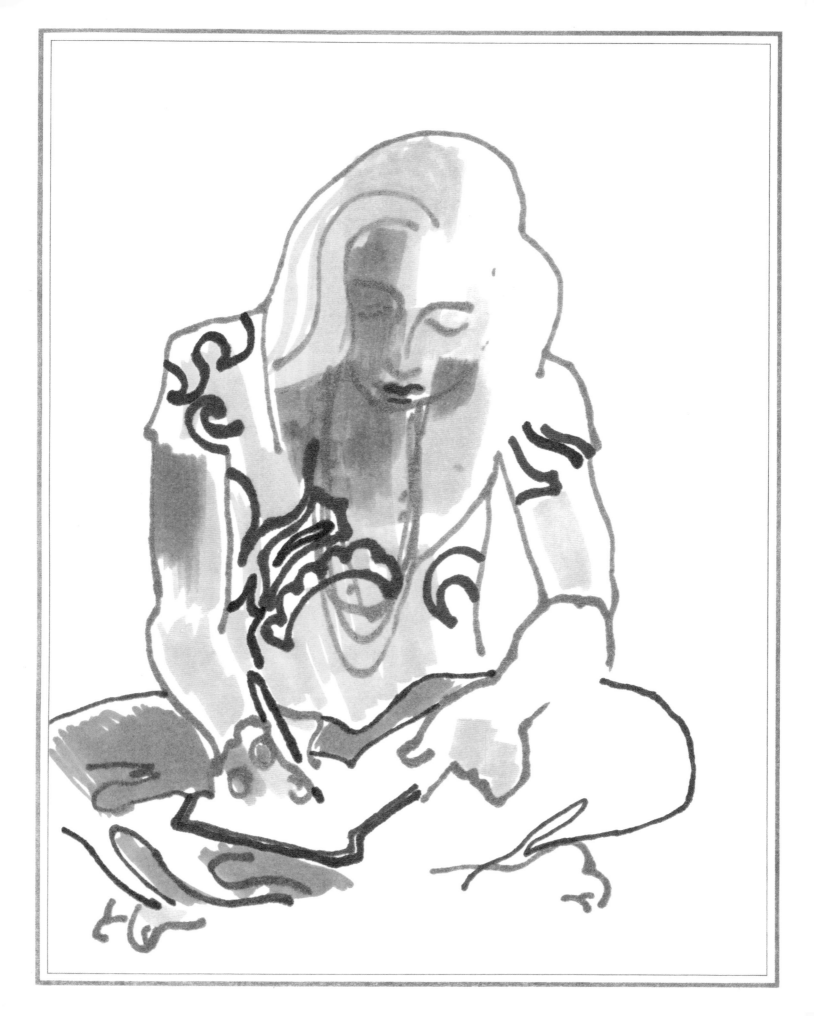

The Ladies of the Canyon

Trina wears her wampum beads
She fills her drawing book with line
Sewing lace on widow's weeds
Fine filigree of leaf and vine
Vine and leaf are filigree
And her coat's a second hand one
Trimmed with antique luxury
She is a lady of the canyon.

Annie sits you down to eat
She always makes you welcome in
Cats and babies round her feet
And all are fat and none are thin
None are thin and all are fat
She may bake some brownies today
Saying, "You are welcome back"
She is another canyon lady.

Estrella, circus girl
Comes wrapped in songs and gypsy shawls
Songs like tiny hammers hurled
At beveled mirrors
In empty halls
Empty halls and beveled mirrors
Sailing seas and climbing banyans
Come out for a visit here
She is another lady of the canyon.

Trina takes her paints and threads
And weaves a pattern all her own
Annie bakes her cakes and her breads
And she gathers flowers for her home
For her home she gathers flowers
And Estrella, dear companion
Colors up the sunshine hours
Pouring her music
Down the canyon.

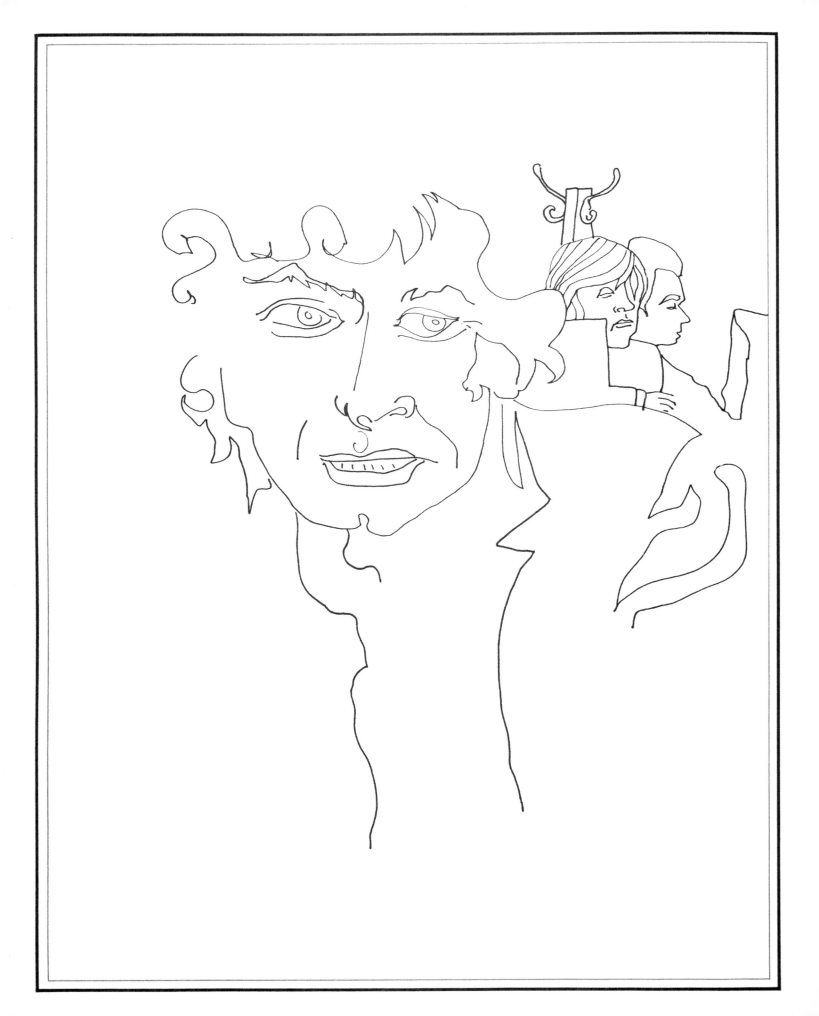

Where is the Thief

Where is the thief
Who did not mean to steal?
Did he leave a clue or trail to follow?
I suppose he's hocked it by now
I remember how he talked about it
Lying on my brocaded couch —
I had pulled up my chair
And was leaning like a secretary
As he dictated —
With some fondness, I noted
The details of his affliction
He said that I should put it away
Out of reach
Lock it up
It was much too tempting
Standing there in the open
Like an offering
When he touched it
You should have seen his face
When he touched it
And the way his fingers hesitated
Before withdrawing.
To his chin.
We talked about alarms
He said he was pleased
That I had one
And I thought indeed he looked relieved
So where is the thief
Who could not help but steal
And where was the burglar bell
I did not hear it peel.

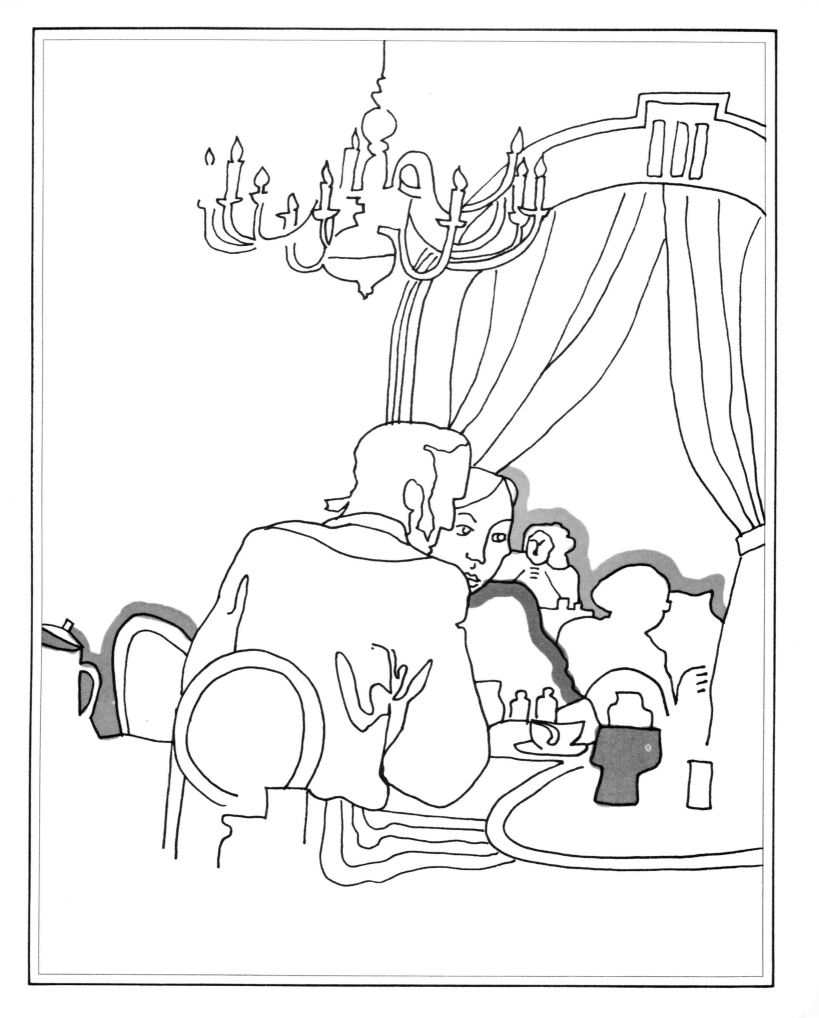

Rooms

All those rooms:
Candle rooms
Sandlewood rooms
Crushing public rooms
All those hotel rooms
The boring and the brass rooms
Time to pass rooms
Empty vast rooms
That echo and clack
Echo and clack
Till the seats are packed
The frontrooms and the rooms in back
The all-night-movie-rooms
Black
The silk-bazaar-rooms-fabrics stacked
Café dining rooms
Pubs and pout and whining rooms
Silent divining rooms
The rooms you left me in
And the bathroom with the tub-water running
And the sunroom with all the flowers sunning
And the fever room
Rejoicing
We are coming.

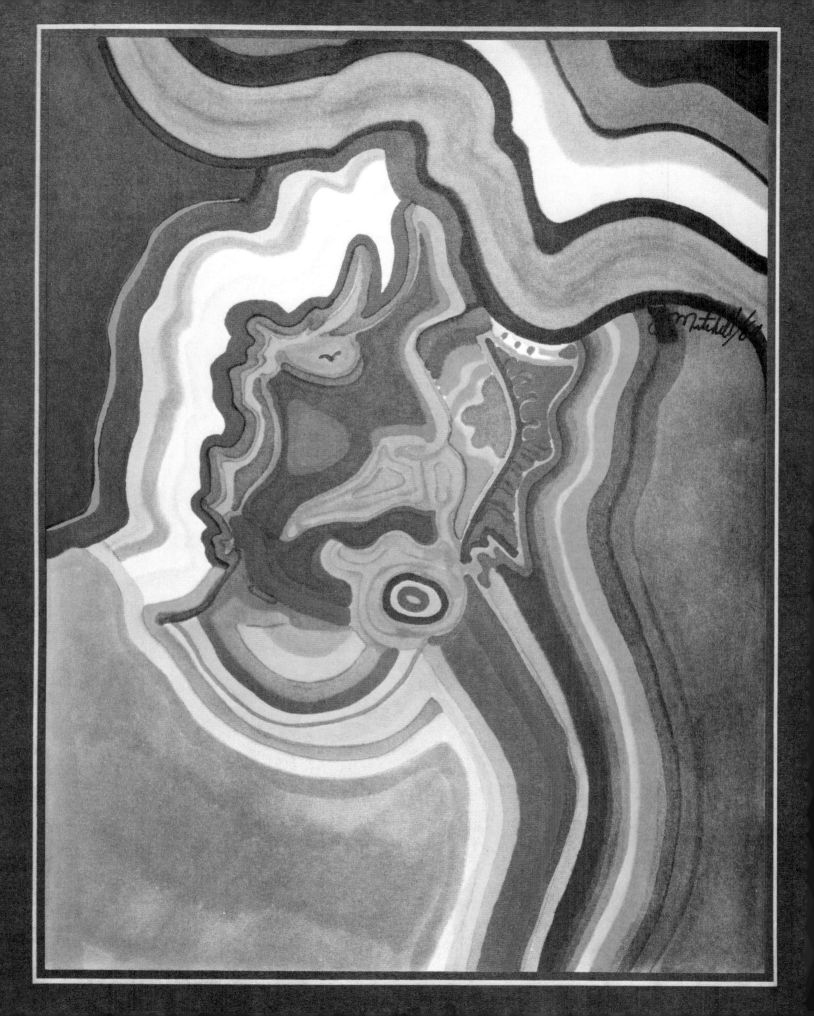

The Priest

The priest sat in the airport bar
He was wearing his fathers' tie
And his eyes looked into my eyes so far
Whenever the words ran dry
Behind the lash and the circles blue
He looked as only a priest can thru
And his eyes said, "Me"
And his eyes said, "You"
And my eyes said, "Let us try."

But he said, "You wouldn't like it here
It's no place you should share
The roof is ripped with hurricanes
And the room is always bare
I need the wind and I seek the cold."
He reached past the wine for my hand to hold
And he saw me young
And he saw me old
And he saw me sitting there.

Then he took his contradictions out
And he splashed them on my brow
So which words was I then to doubt
When choosing how to vow
Should I choose them all
Should I make them mine
The sermons, the lies, and the valentines
He asked for truth
And he asked for time
And he asked for only now

Oh now the trials are trumpet scored
Oh will we pass the test
Or just as one loves more and more
Will one love less and less
Oh come let's run from this ring we're in
Where the christians clap and the lions grin
Crying "Let them lose"
Or "No, let them win."
Oh make them both confess."

Rainy Night House

It was a rainy night
We took a taxi
To your mothers' home
She went to Florida
And left you
With your fathers' gun
Alone
Upon her small white bed
I fell into a dream
You sat up all the night
And watched me
To see
Who in the world I might be.

I am from the Sunday School
I sing soprano
In the upstairs choir
Ah - ah - ah —————
You are a holy man
On the F.M. radio
I sat up all one night
And watched thee
To see
Who in the world you might be.

You called me beautiful
You called your mother
She was very tanned
So you packed your tent and went
To live out in the Arizona sand
You are a refugee
From a wealthy family
You gave up all the golden factories
To see
Who in the world you might be.

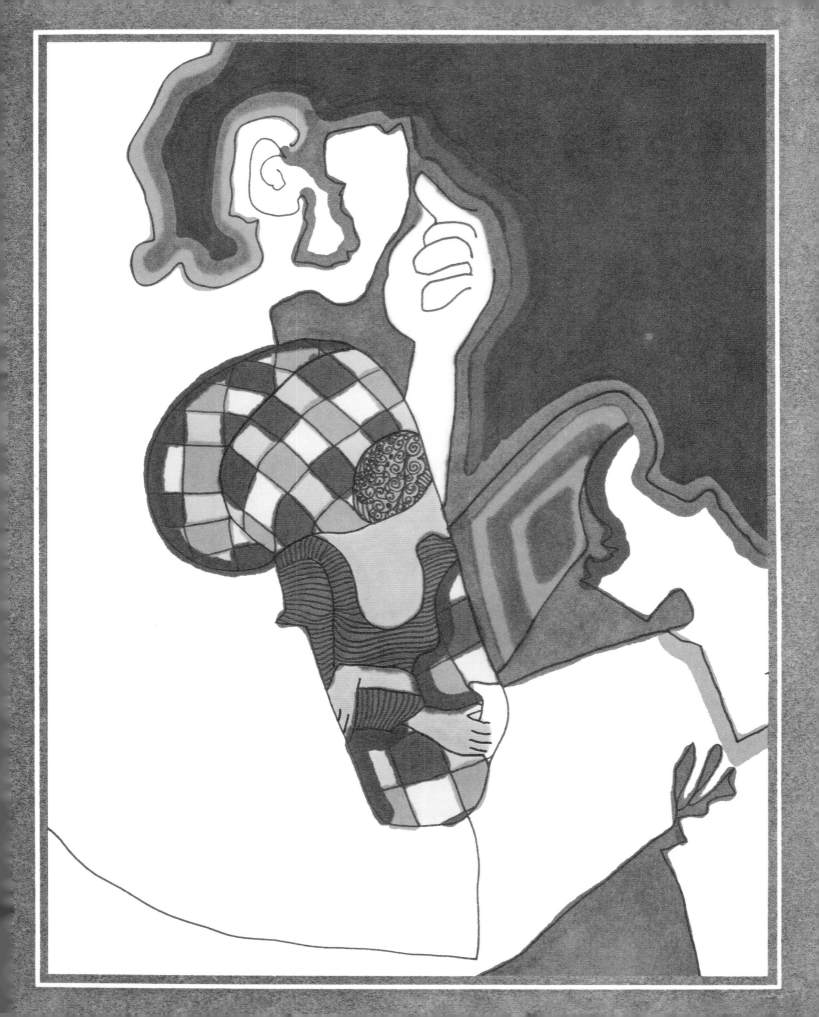

The Gallery

When I first saw your gallery
I liked the ones of ladies
Then you began to hang up me
You studied to portray me
In ice and greens
And old blue jeans
And naked in the roses
Then you got into funny scenes
That all your work discloses

"Lady don't love me now
I am dead
I am a saint
Turn down your bed
I have no heart"
That's what you said
You said "I can be cruel
But let me be gentle with you"

Somewhere in a magazine
I found a page about you
I see that now it's Josephine
Who cannot be without you
I keep your house in fit repair
I dust the portraits daily
Your mail comes here
From everywhere
The writing looks like lady's.

"Lady don't love me now
I am dead
I am a saint
Turn down your bed
I have no heart"
That's what you said
You said "I can be cruel
But let me be gentle with you."

So I gave you all my pretty years
Then I've begon to weather
And I was left to winter here
While you went west for pleasure
And now you're flying back this way
Like some lost homing pidgeon
They've monitored your brain so you say
And charged you with religion
"Lady please love me now
I was dead
You know, I am no saint
Turn down your bed
Lady have you no heart?"
That's what you said
And I said "I can be cruel
Oh, but let me be gentle with you."

When I first saw your gallery
I liked the ones of ladies
But now their faces follow me
And all their eyes look shady.

The Hunter

I was alone and sickly
It was a quarter moon that night
I heard him cry
Thru my window shade
And it filled me so full of fright
But I could not turn my back on him
I put on the backporch light
 "Can I help you?" said the good Samaritan

I brought him bread and a blanket
But I told him "You can't come in.
You can sleep out there in the toolshed
Though a little rain gets in
I don't know you
You're a stranger to me
I don't know where you've been
 You can't come in here."
 Said the keeper of the inn.

Then I couldn't sleep for the thinking
The night got so insane
I thought "Maybe he was an angel
And I left him out in the rain!
What if he was the devil
He'll be coming after me again!"
 But when I woke
 In the weary morning
 He was gone.

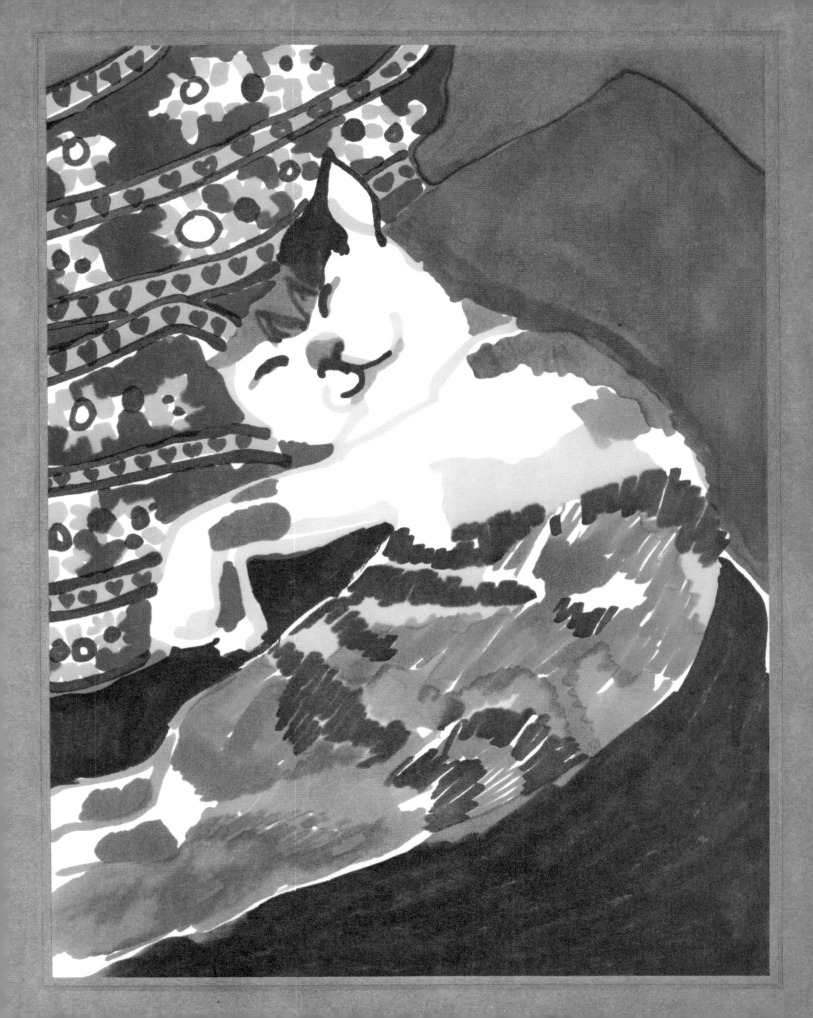

Road Song

A car goes down a hill
And a hubcap comes off
It rolls
And the dog-next-door
Yaps and licks
And his tin dish wobbles
He scratches the screen
Sounding mean
He hollers at the moon
Or the afternoon
Or whatever it is
Behind those blinds.

I will count cars
Like sheep
Beep
Beep
Counting back
Like I did
In hospital beds
Before ether dreams
forty-nine
forty-eight
forty-seven
Cars leaping over fences
Cars grazing the white stripes
Off the asphault pastures
forty-two
Whistling cars
Gamboling around dark
Corners.

thirty - seven
Grinding cars
Coughing cars
Hissing cars
Big - sleek - American cars
Over-steering
Horns blaring
Radios blasting
The star - spangled banner
In a mangled manner.

Go away
Night or day
Go away road song
I am not clapping
Stop your racket.
Pitsicato combustions unending;
Doppler drones suspending;
Convertible crescendos ascending—
Swishing, grinding—
Take your bleating beat
To some other street
It keeps my sleep
In a dotted line
In this stereo night
This high - fidelity day
Or whatever it is
Behind those blinds.

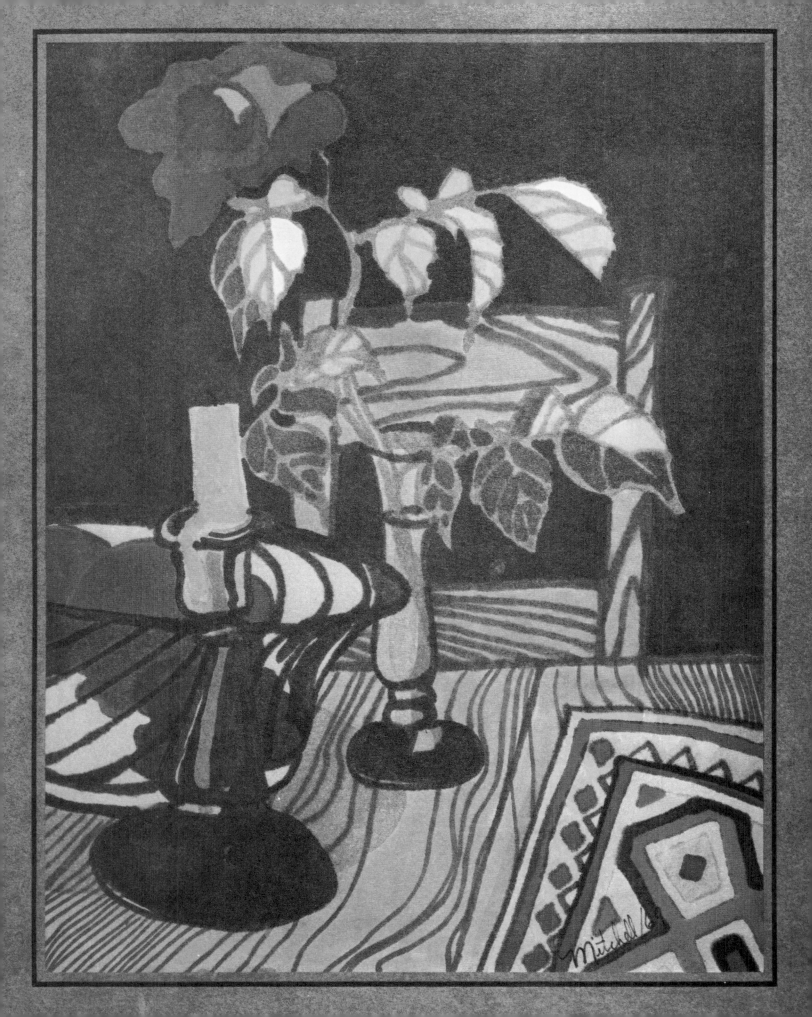

Green Flying Bug

Hello green flying bug
With orange eyes
I saw you once before
Crawling the purple glass
And now that I am sick
And full of sighs
Here you come again
To cheer me with your color
Walking the grass wallpaper
Between the brass bedposts.

A Case of You

Just before our love got lost you said
"I am as constant as a northern star
And I said "Constantly in the darkness —
Where's that at.
If you want me
I'll be in the bar."
On the back of a cartoon coaster
In the blue T.V. screen light
I drew a map of Canada
Oh Canada
With your face sketched on it twice

You are in my blood
Like holy wine
You taste so bitter
And so sweet
Oh I could drink a case of you
Darling
And I would still be on my feet
I would still be on my feet.

I am a lonely painter
I live in a box of paints
I'm frightened by the devil
And I'm drawn to the ones
Who ain't afraid
I remember that time you told me
You said "Love is touching souls —
Well surely you touched mine
'Cause part of you
Pours out of me
In these lines from time to time

I met a woman
She had a mouth like yours
She knew your life
She knew your devils
And your deeds
And she said, "Go to him -
Stay with him if you can, but
Be prepared to bleed"
Oh but

 You are in my blood
 You're my holy wine
 You're so bitter
 Bitter and so sweet
 Oh, I could drink
 A case of you, darling
 And I would still be on my feet
 I would still be on my feet

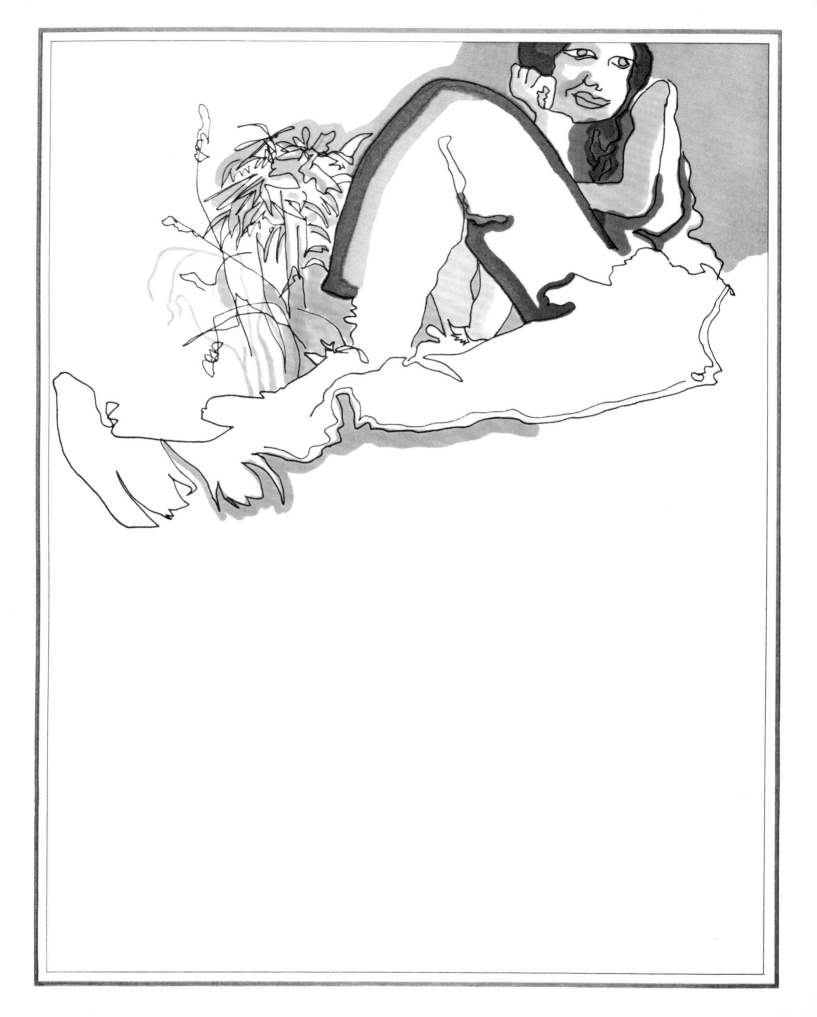

As I lie in my garden thinking... (Aug 2/68)

Flys are scattering their thin shadows
Over my face
Like planes above a planet —
People who die in plane crashes
Come back as flys;
People who die in cave-ins
Turn into crystal;
People who live in sin
Come back as serpants
Crawling on spiny bellys
So gramma says
Over her rimless glasses.

I don't believe in sin
Or serpants for that matter —
They're only guilty ghosts
Come back to tease you
With their clatter
Like the hunter in my hallway
Like the lion that is growing
In my ivy tree.

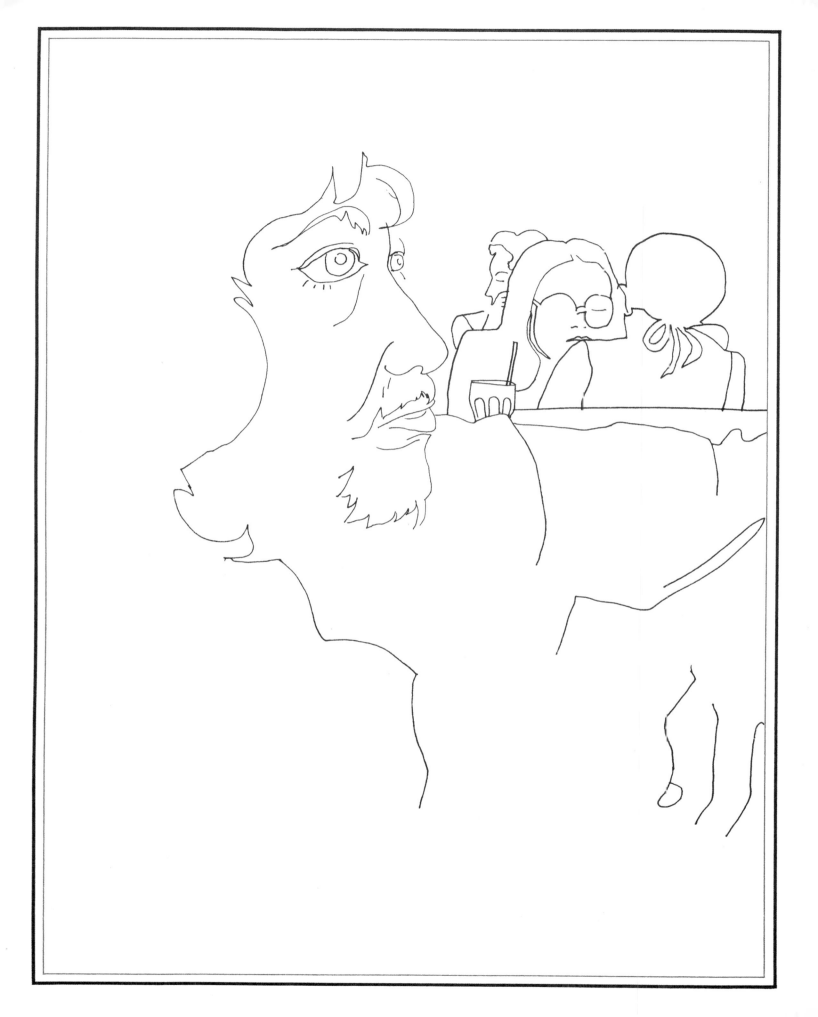

Willy

Willy is my child he is my father
I would be his lady all my life
He said he'd love to live with me
But for an ancient injury
That had not healed
He said "I feel once again
Like I gave my heart too soon"
He stood looking thru the lace
At the face on the conquered moon
And counting all the cars up the hill
And the stars on my window sill
There are still more reasons
 Why I love him.

Willy is my joy he is my sorrow
Now he wants to run away and hide
He says our love cannot be real
He cannot hear the chapels pealing silver bells
But it's so hard to tell
When you're in the spell
If it's wrong or if it's real
But you're bound to lose
 If you let the blues get you scared to feel
And I feel like I'm just being born
Like a shiny light breaking in a storm
There are so many reasons
 Why I love him.

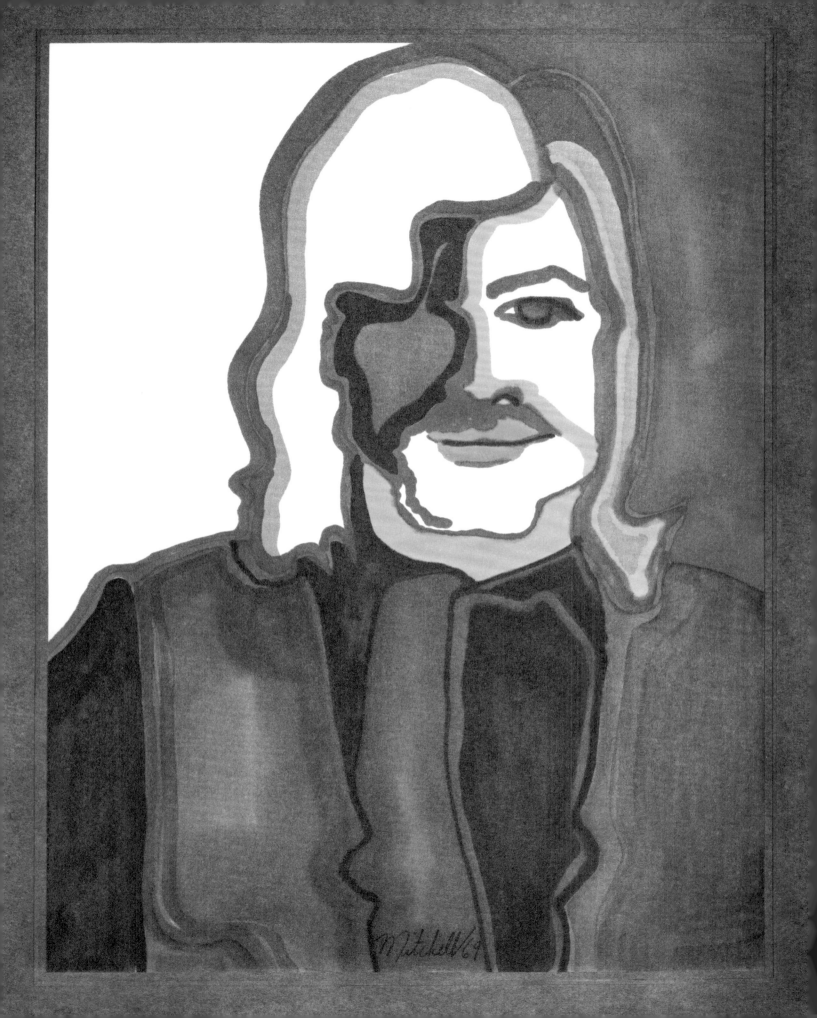

After the Frost

I did love you
Sweet London Bridge
Tattered old lettuce
Me
Morning glory on the vine
Opening and closing
All the time
Opening and closing
All the time.

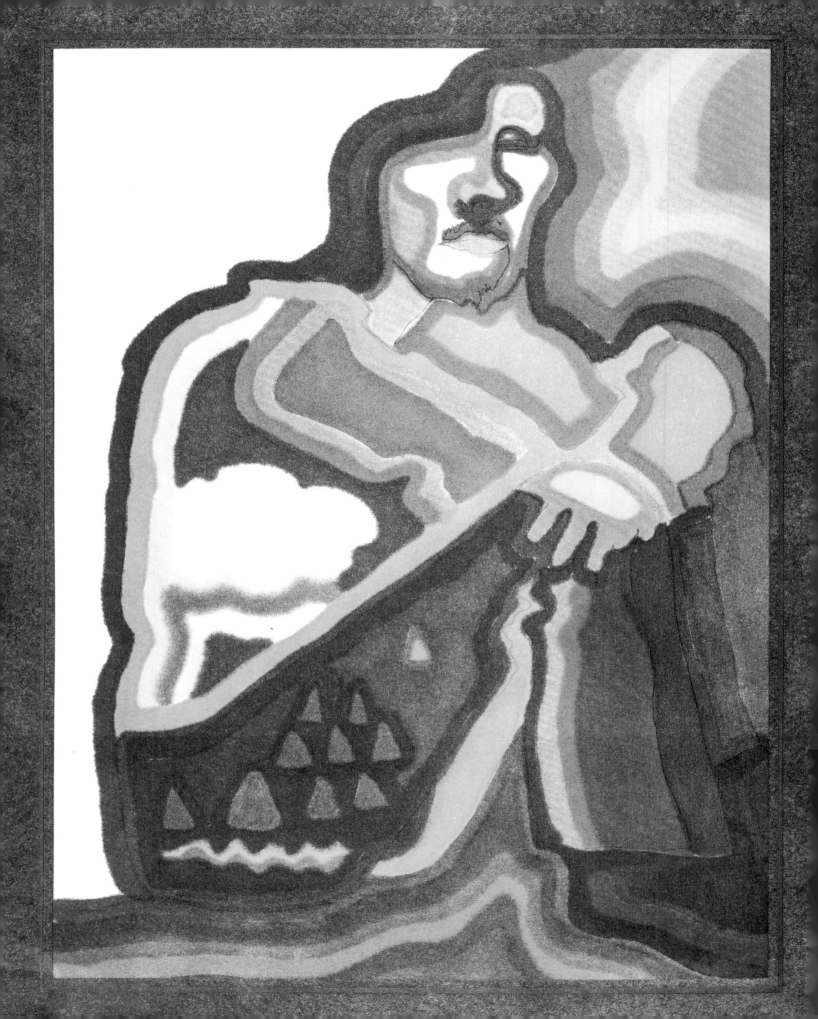

River

It's coming on christmas
They're cutting down trees
They're putting up reindeer
And singing songs of joy and peace
Oh, I wish I had a river
I could skate away on
But it don't snow here
It stays pretty green
I'm going to make a lot of money
Then I'm going to quit this crazy scene
Oh, I wish I had a river
I could skate away on

I wish I had a river
So long
I would teach my feet to fly
Oh I wish I had a river
I made my baby cry.

He tried hard to help me
He put me at ease
He loved me so naughty
Made me weak in the knees
Oh, I wish I had a river
I could skate away on
But I'm so hard to handle
I'm selfish and I'm sad
Now I've gone and lost the best baby
That I ever had
Oh, I wish I had a river
I could skate away on
I wish I had a river
So long
I would teach these feet to fly
Oh I wish I had a river
I made my good baby say goodbye.

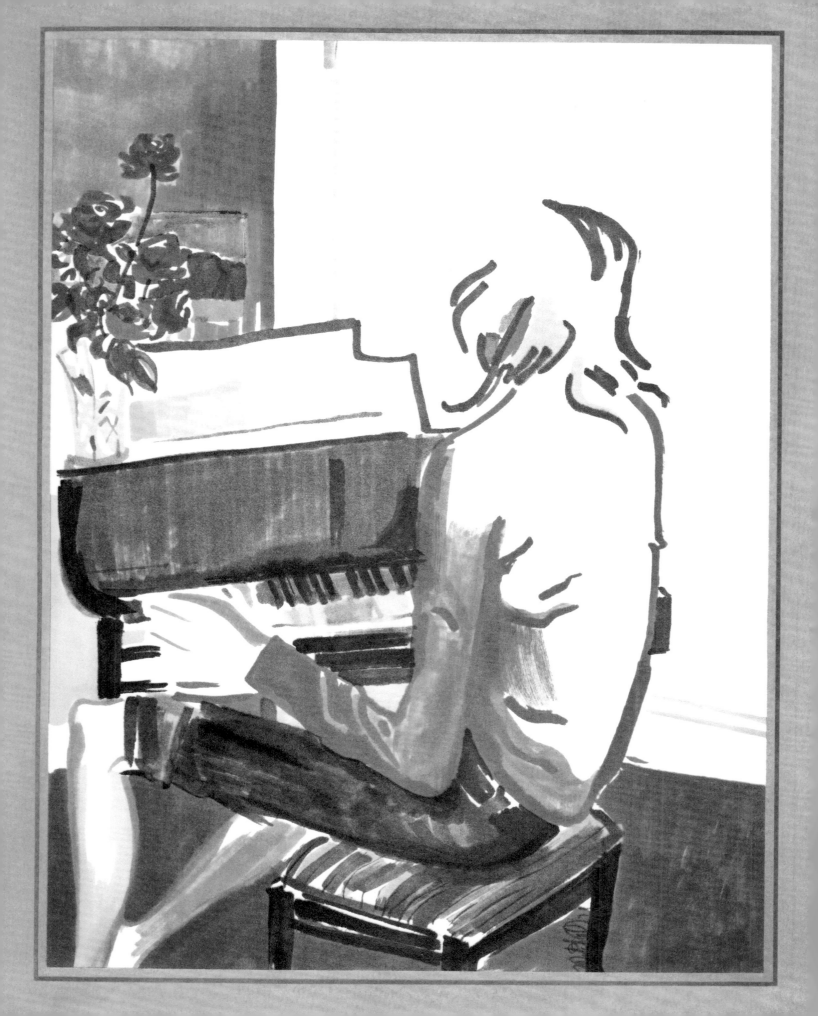

Real Good For Free

I slept last night in a good hotel
I went shopping today for jewels
The wind rushed around in the dirty town
And the children let out from the schools
I was standing on a noisy corner
Waiting for the walking green
Across the street he stood
And he played real good
On his clarinet for free.

Now me, I play for fortunes
And those velvet curtain calls
Got a black limousine
And two gentlemen
Escorting me to all the halls
Now I play if you have the money
Or if you're a friend to me
But the one man band
By the quick lunch stand
He was playing real good for free

Nobody stopped to hear him
Though he played so sweet and high
They knew he'd never been on their T.V.
So they passed his music by
I meant to go over and ask for some song
Maybe put on a harmony
I heard his refrain
As the signal changed
He was playing real good for free.

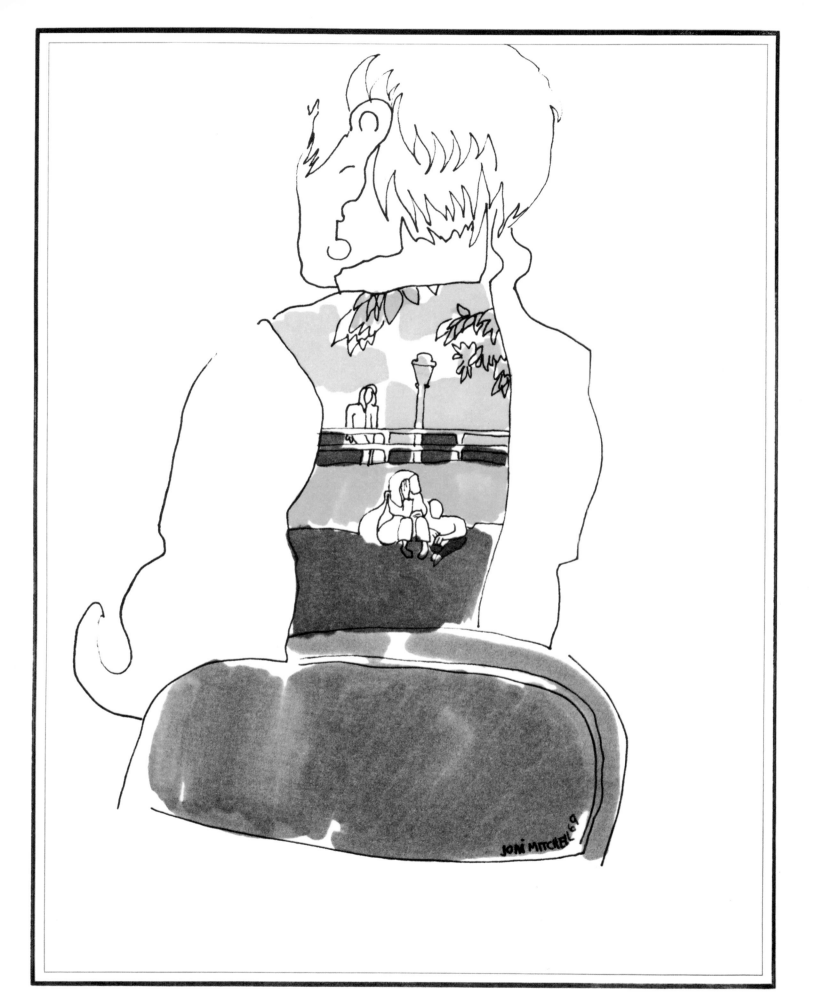

The Louisiana Fiddler

The frenchman
Tucked his turtle-bellied fiddle
(Fourhundred years
 A frenchman's fiddle)
With the abalone inlay round the middle
Under his blue-shadowed chin
And his knees and his elbows
Changed their angles
Like compases tracing spirals
On old wooden desk tops
The old wooden fiddle
Hey diddle, diddle
With the abalone inlay round the middle
Under the thin blue chin
Under the thin lipped grin
Under the oh-la-la eyes
Under the sweet pressure
Of his do-si-do bow
Fourhundred years a frenchman's fiddle
It cried what he told it to
Over his tap tap toes.

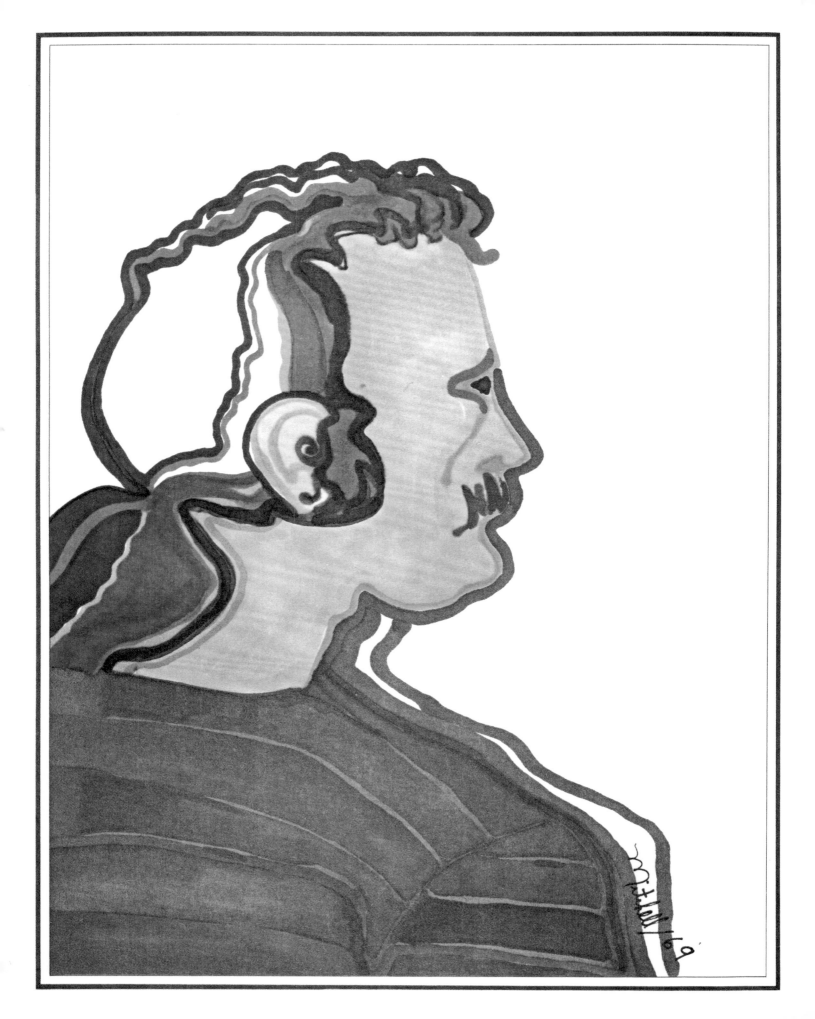

The Arrangement

You could have been more
Than a name on the door
On the thirty-third floor
In the air
More than a credit card
Swimming pool in the back yard
While you still have the time
You could get away
And find a better life
You know the grind is so ungrateful
Racing cars
Whisky bars
No one cares
Who you really are —
You're the keeper of the cards
Yes I know it gets hard
Keeping those wheels turning
And the wife she keeps the keys
She is so pleased to be
A part of the whole arrangement.

You could have been more.
Than a name on a door
On the thirty-third floor
In the air —
More than a consumer
Lying in some room
Trying to die
More than a credit card
Swimming pool in the back yard.

Cary

The wind is in from Africa
Last night I couldn't sleep
Oh you know, it sure is hard to leave here
But it's really not my home
My fingernails are filthy
I've got beach tar on my feet
And I miss my clean white linen
And my fancy french cologne
 Cary get out your cane
 And I'll put on some silver
 You know, you're a mean old Daddy
 But I like you fine.

Come on down to the Mermaid Cafe
And I will buy you a bottle of wine
And we'll laugh and toast to nothing
And smash our empty glasses down
Lets have a round for these freaks
And these soldiers
A round for these friends of mine
Let's have another round for the bright red devil
Who keeps me in this tourist town
 Oh Cary get out your cane
 And I'll put on some silver
 Oh you're a mean old Daddy
 But I like you fine.

Maybe I'll go to Amsterdam
Maybe I'll go to Rome
And rent me a grand piano
And put some flowers round the room
But let's not talk about fare-thee-wells now
The night is a starry dome
And they're playing that scratchy rock'n'roll
Beneath the Matalla moon

 Oh Cary get out your cane
 And I'll put on my silver
 You're a mean one - Ornery
 But I like you fine.

The wind is in from Africa
The sea is full of sheep
It sure is hard to leave here Cary
But it's not my home
Maybe it's been too long a time
Since I was scrambling
Down in the streets
Now they got me used to that clean white linen
And that fancy french cologne.

 Oh Cary get up, get your cane
 And I'll put on my finest silver
 We'll go to the Mermaid cafe
 Have fun tonight
 Oh you're a mean old daddy
 But you're out-a-site!

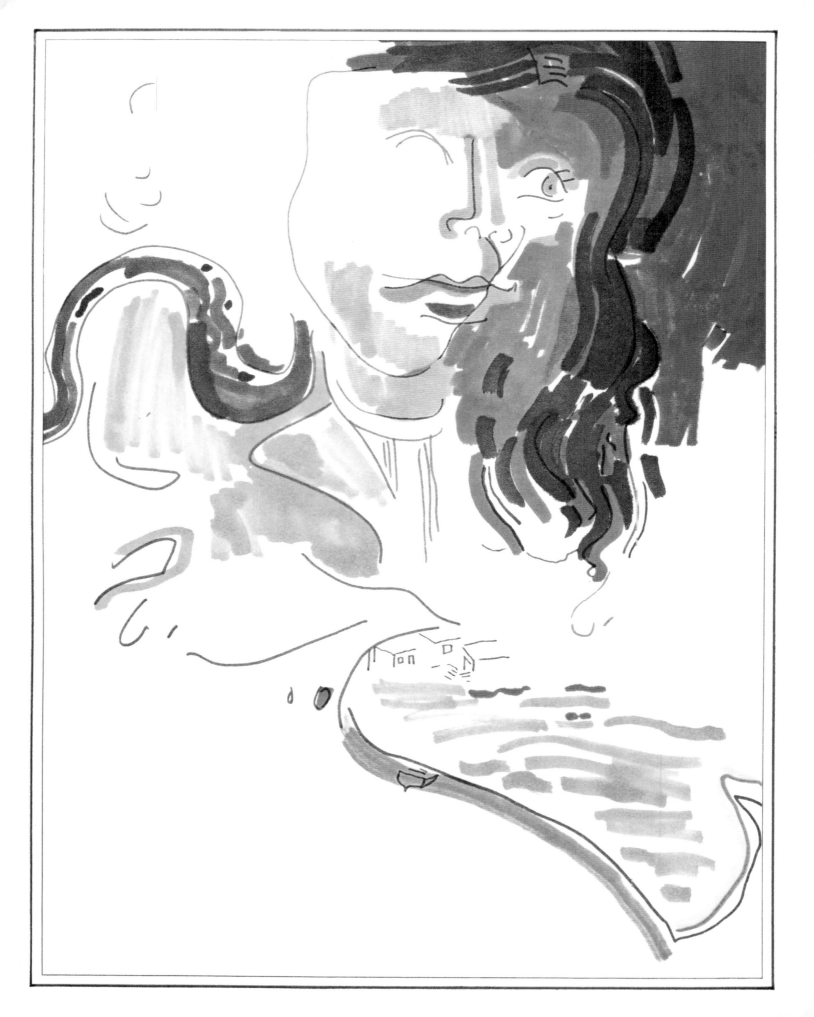

Penelope

Penelope wants to fuck the sea
Tired of waiting
Tired of the stitches
In her tapestry
She spreads
Goosebumps on her winter flesh
Foam
Licking at her up the stone
Salt on its teasing tongue
It comes
Wide blue lipped
Hissing
Wet hissing
Like electric Jaggar
It comes in spurts
It waves obscene
She wrinkles up her nose and screams
A haunted laugh
That rocks the rocks
And calls in metaphors
For metamorphic cocks.

Matalla Moon

Full moon over Matalla
Calm water bay
Brooding
Wrapped in grey
Blanket
Blues
I sit in a black hole
Confused
Sleep little darlin'
Don't you cry
Beatles down at the 'Greeks'
Scratch
Scratch
Scratch
Lullaby
Beach fire in embers
Empty
My life a club hall
Chairs stacked up
No members
No names to remember.

Full moon over Matalla
Full moon on the bay
Valerie
Naked
Spreading
From Mickey Mouse chocolate bars
And Doras' apple pie each day
Comes out of her cave
With a bump she comes
A wave rolls in
Like a burlesque drum

The moon shines on her
I put out my smoke
Something primal moves me
Something makes a joke —
She straddles the cliffs
Pisses for the stars
Yawns
Shakes her hips
Slips thru plastic and bamboo
I hear her rummaging
I hear her trip
I hear her mummy bag zip.

The asshole has me sleeping on the floor —
All night small thieves runnin and out the door —
Drop fleas
Rip us off for cheese
And all the dayold beanstew
They can score.

Hydra

Bored with boats
And worry beads
We launch ourselves
On the night street stream
Smashing our bows with beer
We laugh in the fishy blue room.
She recites her poetry
While I hum Claire de Lune.

California

Sitting in a park in Paris France
Reading the news and it's so bad
They won't give peace a chance
That was just a dream some of us had
Still a lot of lands to see
But I wouldn't want to stay here
It's too old and cold and settled in its ways here
Oh but California
California I'm coming home
I'm going to see the folks I dig
I'll even kiss a sunset pig
California I'm coming home

I met a redneck on a Grecian isle
Who did the goat dance very well
He gave me back my smile
But he kept my camera to sell
Oh the rogue the red red rogue
He cooked good omelettes and stews
And I might have stayed on with him there
But my heart cried out for you
California
California I'm coming home
Make me feel good rock 'n' roll band
I'm your biggest fan
California I'm coming home.

Oh it gets so lonely
When you're walking
And the streets are full of strangers
All the news of home you read
Just gives you the blues.....

So I bought me a ticket
I caught a plane to Spain
Went to a party down a red dirt road
There were lots of pretty people there
Reading Rolling Stone
Reading Vogue
They said how long can you hang around
I said a week maybe two
Just until my skin turns brown
Then I'm going home
To California
California I'm coming home
Will you take me as I am
Strung out on another man
California I'm coming home

Oh it gets so lonely
When you're walking
And the streets are full of strangers
All the news of home you read
More about the war
And the bloody changes –
Will you take me as I am
Will you take me as I am
Will you

The Banquet

Come to the dinner gong
The table is laden high
Fat guts and hungry little ones
Tuck your napkins in
And take your share
Some get the gravy
Some get the gristle
Some get the marrow bone
And some get nothing
Though there's plenty there to share
 I took my share down by the sea
 Paper plates and Javex bottles on the tide
 Seagulls come down and they squawk at me
 Down where the water skiers glide

Some turn to Jesus
Some turn to Heroin
Some turn to rambling round
Looking for a clean sky
And a clear drinking stream
Some watch the paint peel off
Some watch their kids grow up
Some watch their stocks and bonds
Waiting for that big deal American dream
 I took my dream down by the sea
 Yankee yachts and lobster pots and sunshine
 And logs and sails and Shell Oil pails
 Dogs and tugs and summertime —
 Back in the banquet line
 Angry young people crying

Who let the greedy in
And who left the needy out
Who made this salty soup
Tell him we're hungry now
For a sweeter fare.
In the cookie I read
"Some get the gravy
Some get the gristle
Some get the marrow bone
And some get nothing."

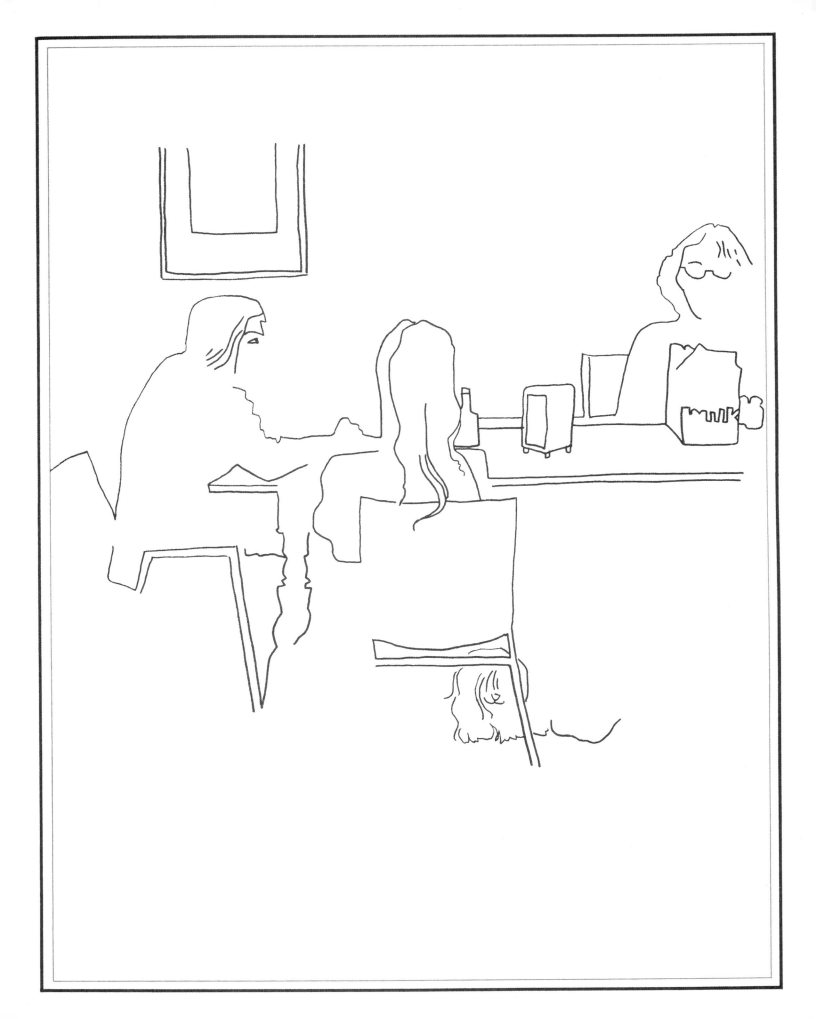

Applause, Applause

Made in Mexico
By hand
 Your sandles
Jap time
By the microphone stand
 Your flashlight gaze
 Shines into applause
And plays
Cool
Clean
Long and lean
Dark deep water
Blue and green.

I drink your tunes
Like rain
And grow to you
Thru dirt
Like any flower
No —
More quickly
Like a weed I grow
Some foxtail in the field
I blow
Careless
Then careful
Careless
Then careful.
You seem some similar
Rumpled breed
Some tumble weed —
I've been to seed
And scarred
Applause
Are you too vain
To love on the stem
The patterns of pain?

Come here
Long wind
Or tweed
Or whatever —
Come gentle from the south
And run your tongue
Along my mouth
Applause
Applause
Love is our cause
We are without it now
A pause.

Backstage the Bettys prune
They'll wet their lips
And rush to praise you soon
Applause
That embryo colleen
And other nipples on the scene
That vegetarian
With the celery eyes
Bet her friend
She'll feel you rise
Tonight
She's a child
She followed us all day
Everytime we slipped away
She sees her head upon your pillow
Not tonight child —
Not with this wild willow
Watching
In amps and cables
Chewing black cherrys at the press table
Dreaming her own romantic fables
Applause, Applause, Applause
The crowded clapping lawn
Raves on and on
Find me when the fans are gone
I need to meet you in the dark
To build some kind of bond.

All I want

I am on a lonely road
And I am travelling
Looking for something
What can it be?
Oh I hate you some
I hate you some
I love you some
I love you when I forget about me –
I want to be strong
I want to laugh along
I want to belong to the living
Alive, Alive
I want to get up and jive
I want to wreck my stockings
In some juke box dive
Do you want
Do you want
Do you want to dance with me baby?
Do you want to take a chance
On sweet romance with me baby?
Come on!

All I really really want
Our love to do
Is to bring out the best in me
And in you too
All I really really want
Our love to do
Is to bring out the best in me and in you –
I want to talk to you
I want to shampoo you
I want to renew you again and again
Applause, Applause
Life is our cause
When I think of your kisses
My mind see-saws
Do you see
Do you see
Do you see how you hurt me baby?
So I hurt you
Then we both get so blue
Come on now!

I am on a lonely road
And I am travelling
Looking for the key
To set me free
Oh the jealousy
The greed is the unravelling
It undoes all the joy that I could be —
I want to have fun
I want to shine like the sun
I want to be the one
That you want to see
I want to knit you a sweater
Write you a love letter
Make you feel better
I want to make you feel

free

My Old Man

My old man
He's a singer in the park
He's a walker in the rain
He's a dancer in the dark
 We don't need
 No piece of paper
 From the city hall
 Keeping us tied and true
My old man
Keeping away my blues.

He's my sunshine in the morning
He's my fireworks at the end of the day
He's the warmest chord I ever heard
Play that warm chord and stay baby
 We don't need
 No piece of paper
 From the city hall
 Keeping us tied and true
My old man
Keeping away my blues
 But when he's gone
 Me and them lonesome blues collide
 The bed's too big
 The frying pan's too wide...

Then he comes home
And he takes me in his lovin' arms
And he tells me all his troubles
And he tells me all my charms
 We don't need
 No piece of paper
 From the city hall
 Keeping us tied and true
My old man
Keeping away my lonesome blues.

Company

What a great toll-gate-clatter
And swirling of grape juice
Has sprung up on my veranda
Since distant cousins
And distant fans
And the third-girl-
Fifth-row-from-the-bottom-
Sixth grade
And great Aunt Myrna
Have joined the jet set.

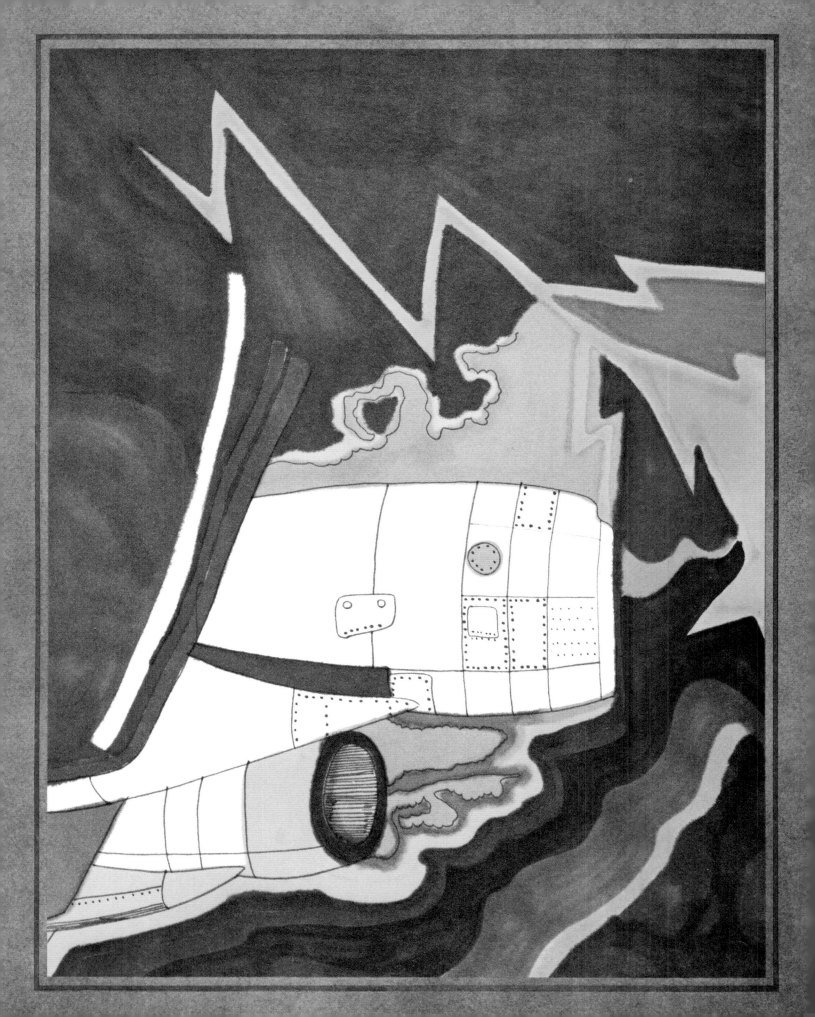

A Plane is a Bird ...

A plane is a bird
That when singing
 has no soul –
When winging
 it has a pilot in the pit.
Like a spirit in the spit
Of waters
Split
Fits on rocks
Buzzing docks
Mad hawks and seabirds
Gather in the sky like storms
Swarming the warm jet winds
Warning the sky master
That now he has gone too far!
Now with the high sky dying
Choked with smoke
And other heartless jokes
They gather in circles
 And croak,
 croak
 croak
They gather together
 And croak

This Flight Tonight

"Look out the left"
The captain said
"Those lights down there
That's where we'll land."
I saw a falling star burn up
Above the [Las] Vegas sands
It wasn't the one
That you gave to me
That night down south
Between the trailers
Not the early one
That you can wish upon
Not the northern one
That guides in the sailors.

You've got the touch
So gentle and sweet
But you've got that look so critical
I can't talk to you
I get so weak
Sometimes I think love is mythical
Up there's the heavens
Down there's a town
Blackness everywhere
And little lights shining
Blackness
Blackness
Dragging me down
Come on — light the candle
In this poor heart of mine.

I'm drinking sweet champagne
Got the headphones up high
Can't numb you out
Can't drum you out of my mind
They're playing —
 "Goodbye baby
 Baby goodbye
 Ooh, ooh, love is blind"
Up go the flaps
Down go the wheels
I hope you've got your heat turned on, baby,
I hope they finally fixed
Your automobile
I hope it's better
When we meet again, baby.

 Star bright
 Star bright
 You've got the lovin'
 That I like, allright
 Turn this crazy bird around
 I shouldn't have got on this flight
 Tonight.

I'm a Radio

If you're driving into town
With a dark cloud above you
Dial in the number
Who's bound to love you
Honey, you turn me on
I'm a radio
I'm a country station
I'm a little bit corny
I'm a wildwood flower
　　waving for you
I'm a broadcasting tower
　　waving for you
And I'm sending you out this signal here
I hope you can pick it up loud and clear:

I know you don't like weak women
You get bored so quick
And you don't like strong women
Cause they're hip to your tricks
It's been dirty for dirty down the line
But you know I come when you whistle
When you're lovin' and kind—
If you've still got too many doubts
If there's no good reception there
Then tune me out
Cause honey, who needs the static—
It hurts the head
And then you wind up cracking
And the day goes dismal
From "Breakfast Barney"
To the sign off prayer

What a sorry face
You get to wear
I'm going to tell you again
If you're still listening there
Oh honey, you turn me on!
So if you're driving into town
With a dark cloud above you
Dial in the number
Who's bound to love you —
If you're lying on the beach
With the transistor going
Kick off the sandflies sweetheart
The love's still flowing
If your head says "Forget it!"
But your heart's still smoking
Call me at this station
The lines are open.

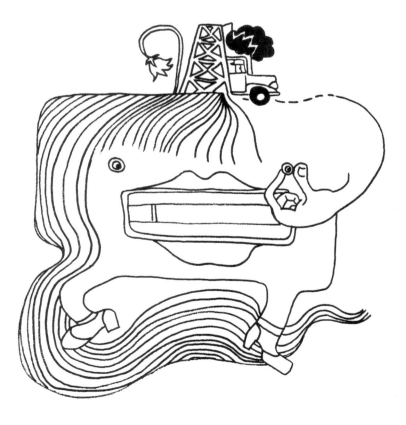

For the Roses

I heard it in the wind last night
It sounded like applause
Did you get a round resounding for you
Way up here?
It seems like many dim years ago
Since I heard that—face to face
Or seen you—face to face
Though tonight I can feel you here.

 I get these notes
 On butterflies
 And lilac sprays
 From girls
 Who just have to tell me
 They saw you somewhere . . .

In some office sits a poet
And he trembles as he sings
And he asks some guy
To circulate his soul around
On your mark — red ribbon runner
The caressing rev of motors
Finely tuned like fancy women
In thirties evening gowns
 Up the charts
 Off to the airport
 The attention's fun
 But it's mostly phoney
 Or maybe you don't know
 What's real anymore
 Except the best hotels
 Are lonely

Remember the days
When you used to sit
And make up your tunes for love
And pour your simple sorrow
To the soundhole and your knee
And now you're seen on giant screens
And at parties for the press
And for people who have slices of you
From the company

 They toss around
 Your latest golden egg
 Speculation!
Well, who's to know
If the next one in the nest
Will glitter for them so

I guess I seem ungrateful
With my teeth sunk in the hand
That brings me things
I really can't give up just yet
So I sit up there — the critic
And they introduce some band
But they seem so much confetti
Looking at them on my T. V. set

 Oh the power and the glory
 Just when you're getting a taste for worship
 They start bringing out their hammers
 And the boards and the nails

I heard it in the wind last night
It sounded like applause
Chilly now — end of summer
No more shiny hot nights
It was just the madrones rustling
And the bumping of the logs
And the moon
Swept down black water
Like an empty spotlight.

The Midway

I met you on a midway
At a fair last year
And you stood out
Like a ruby
In a black man's ear
You were playing on the horses
You were playing on the guitar strings
You were playing like a devil
Wearing wings
Wearing wings
You looked so grand
Wearing wings
Do you tape them to your shoulders
Just to sing?
Can you fly?
I heard you can
Can you fly?
Like an eagle
Doing your hunting from the sky

I followed with the sideshows
To another town
And I found you in a trailor
On the camping grounds
You were betting on some young lover
You were shaking up the dice
And I thought I saw you cheating
Once or twice
Once or twice —
I heard your bid
Once or twice
Were you wondering
"Is the gamble worth the price?"

Pack it in
I heard you did
So you packed it in.
Was it hard to fold a hand
That you knew could win?

So lately you've been hiding
It was somewhere in the news
And I'm still at these races
With my ticket stubs
And my blues
And a voice calls out the numbers
And he sometimes mentions mine
And I feel like I've been working
Overtime.
Overtime
I've lost my fire now
Overtime
Always playing one more hand
For one more dime
I'm slowing down
Getting tired now
Slowing down
And I envy you
That valley that you found
'Cause I'm midway
Down the midway
And I'm slowing down.

I'd Like To See You

Where are you now?
Are you in some hotel room?
Does it have a view?
Are you caught in a crowd?
Or holding some honey
Who came on to you?
Why do you have to be so jive?...
O.K. hang up the phone
It hurts but something survives
Though it's undermined
I would still like to see you sometime.

I'm feeling so good
And my friends all tell me
That I'm looking fine
I run in the woods
I spring from the boulders
Like a mama lion
I'm not ready to change my name
But you know I'm not after
A piece of your fortune and fame
Cause I tasted mine
I'd just like to see you sometime.

We're in for more rain
I could use some good sunshine
On my apple trees
It seems such a shame
That we start off so kind
And end so heartlessly
I couldn't take them all on then
With a headful of questions and hypes
So when the hope got so slim
I just resigned
But I'd sure like to see you sometime

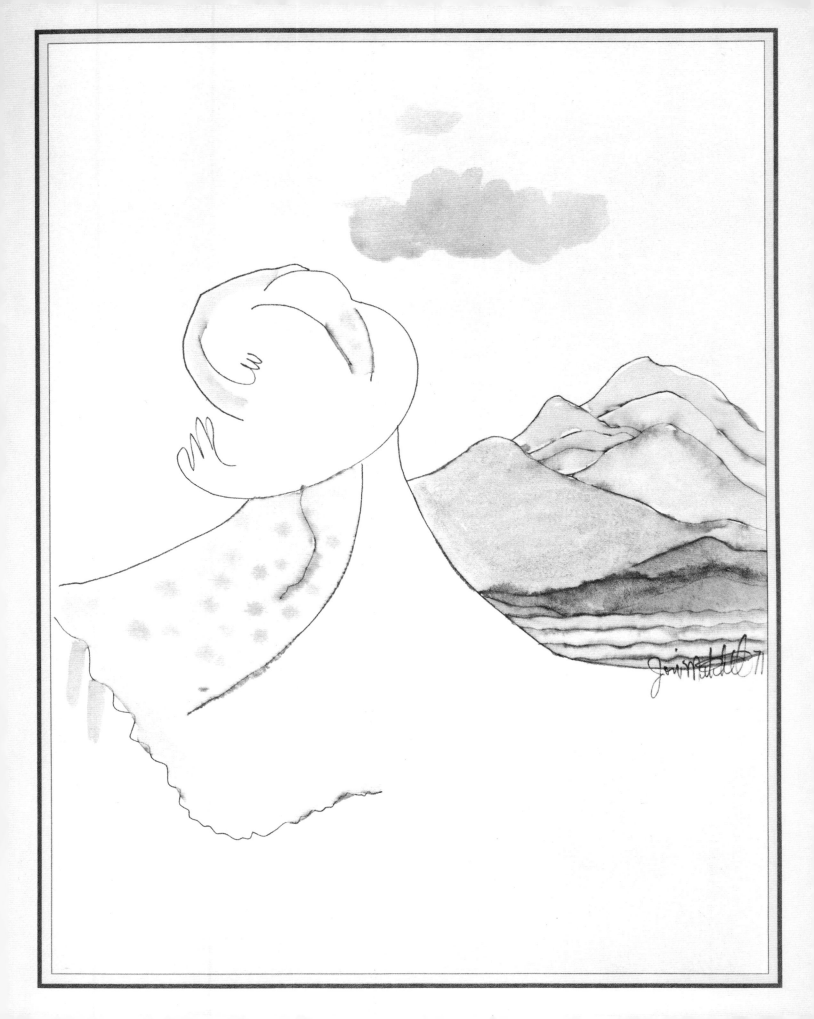

Lesson in Survival

Lesson in survival
Spinning out on turns
That gets you tough
Guru books – the Bible
Only a reminder
That your just not good enough
You need to believe in something
Once I could in our love
Black road double yellow line
Friends and kin
Campers in the kitchen
O.K. but not all the time –
I know my needs
My sweet tumbleweed
I need more quiet times
By a river flowing
You and me
Deep kisses
And the sun going down.

Maybe it's my paranoia
Maybe it's sensitivity
Your friends protect you
Scrutinize me
I get so damn timid
Not at all the spirit
That's inside of me
Baby I can't seem to make it with you
Socially
There's this reef around me

I'm looking way out at the ocean
Love to see that green water in motion
I'm going to get a boat
And we can row it
If you ever get the notion
To be needed by me
Fresh salmon frying
And the tide rolling in.

I went to see a friend tonight
Was very late when I walked in
My talking as it rambled
Revealed suspicious reasoning
The visit seemed to darken him
I came in as bright
As a neon light
And I burned out
Right there before him
I told him these things
I'm telling you now
I watched them buckle up
In his brow
When you dig down deep
You lose good sleep
And it makes you heavy company
I will always love you
Hands alike
Magnet and iron
The souls.

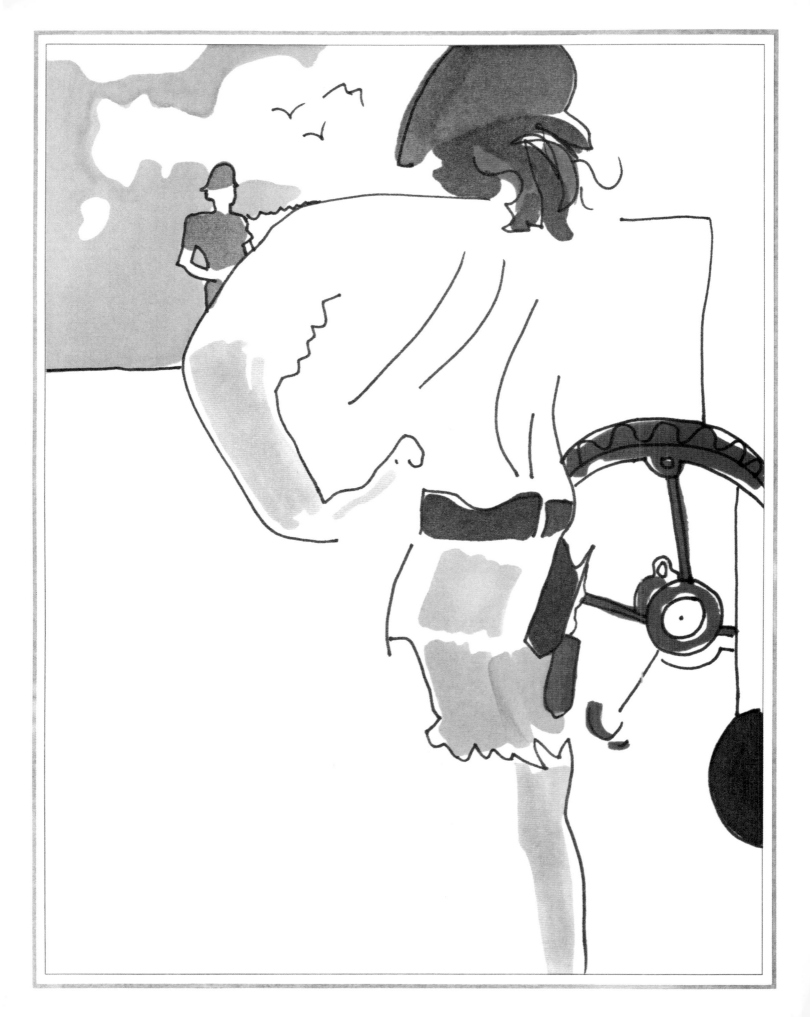

The Uprising Fantasy

Bring us up out of the sewer
Like shining rats
And this time let them follow
To our piper's tunes
They with their brute clubs concealed
Behind their cardboard honor
We will not honor that honor now brutes!
The brutes courtsy to our numbers
Like milkmaids under their ribbons
At a spring festival —
They dance behind our piper
Take off your steel-toed boots
And follow brutes.
Follow barefoot with a flower in your ear
Like an army of Crusoes
Coughed up
From the broken belly of a storm.

Bring us up now like shining rats
For in the sewer or the cage
We sleep upon the printed page
And litter on the headlines rage.

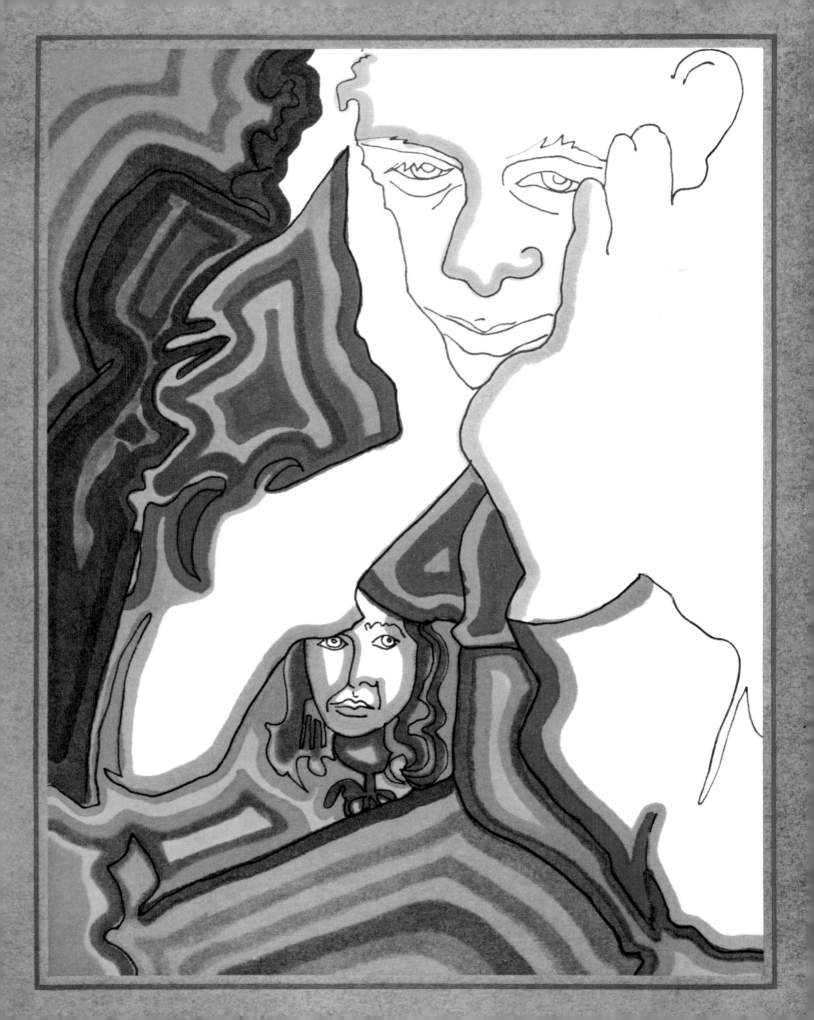

Electricity

The minus is loveless
He talks to the land
The leaves fall - the pond over-ices
"She don't 'know' the system
Plus- she don't understand
She's got all the wrong fuses and splices
No she's not going to 'fix it that way.'"

The masking tape tangles
Its sticky and black
And the copper - proud headed Queen Lizzie
Conducts little charges
That don't get charged back
"Well, the technical manual's busy
She's not going to fix things so easy
 She holds out her flashlight
 And she shines it on me
 She wants me to tell her
 What the trouble might be
 But I'm learning - it's peaceful
 With a good dog and some trees
 Out of touch with the breakdown
 Of this century
 They're not going to fix things too easy.

We once loved together
And we floodlit that time
Input - output - electricity
But the lines overloaded
And the sparks started flying
And the loose wires were blacking out at me
No she's not going to fix that 'so easy."
 She holds out her candle
 And she shines it in
 And she begs him to show her
 How to fix it again
 While the song that he sang her
 To soothe her to sleep
 Runs all through her circuits
 Like a heartbeat
 No she's not going to fix that so easy.

On Solitary Solution

An argument meets in my head
I'm trying to be just
I measure on a balance scale
The evidential dust
I guilty and not guilty plead
I tell me not to worry
Defendant and defender
I am my own judge and jury
And all these points of view speak out
All night behind my eyes
While businessmen
In astrojets
Iso blinking thru the skies.

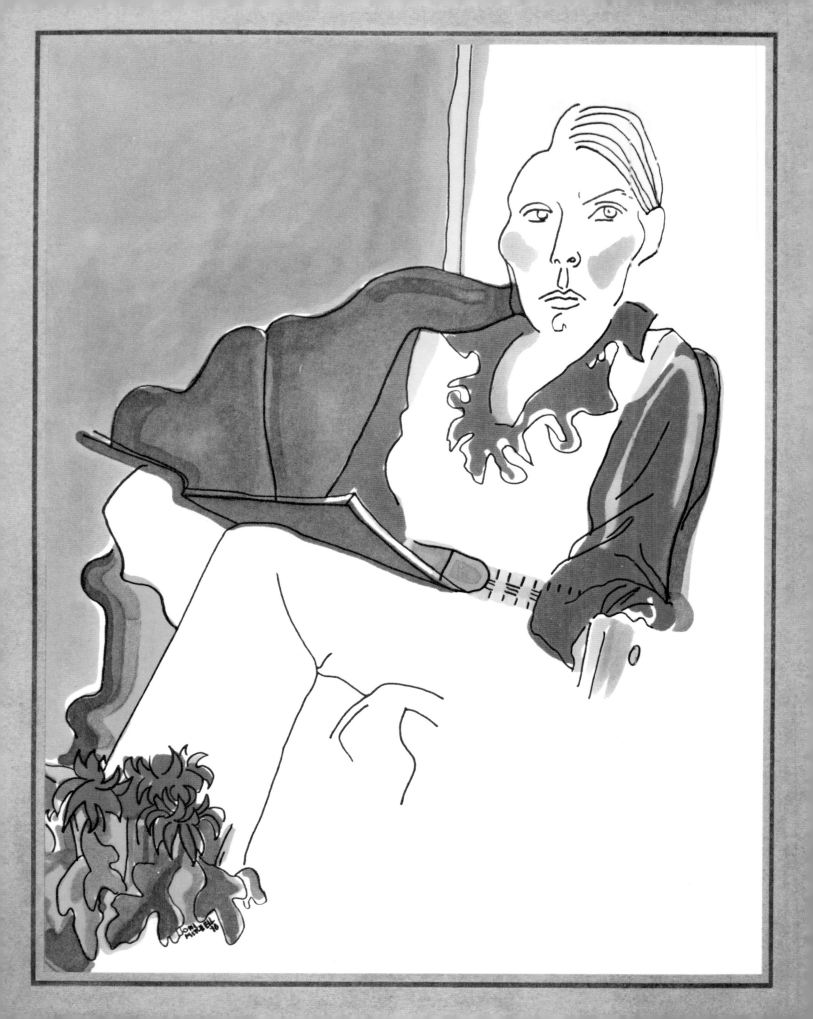

Like Veils

"Life is like veils you tear off," said Lorraine
"No, it's walls we put up", said that tired voice again
The chisel gets blunt
And the sword gets profane
You soak up the stain
And bind up the stone chips
In the gauze that you've slain.

You get so discouraged trying to cut thru it all
More veils beyond veils
Always walls behind the walls
"Get back in there!" yells the golden glove
"When will you trust me," slams the friend
"Learn how to bend!"
"Don't you worry now," soothes the sweet lover
With his medicine hands.

I don't want to grow narrow
And foolish in old age
And miss all that beauty
That wisdom and the grace
And you know you don't get that
From high finance or fame - if you're stuck in that frame
Or the paint that you put
On your face or your name.
"Life is like veils," said Lorraine.

Roses Blue

I think of tears
I think of rain on shingles
I think of rain
I think of Roses Blue
I think of Rose
My heart begins to tremble
To see the place
She's lately gotten to.

She's gotten to
Mysterious devotions
She's gotten to
The zodiac and zen
She's gotten into
Tarot cards and potions
She's laying her religion
On her friends

Friends who come
To ask her for their future
Friends who come
To find they can't be friends
Because of signs
Or seasons that don't suit her
She'll prophesy your death
But she won't say when

When all the black cards come
You cannot barter
When all your stars are stacked
You cannot win
She'll shake her head
And treat you like a martyr
It is her blackest spell
She puts you in.

In sorrow
She can lure you where she wants you
Inside your own self pity
There you swim
In sinking down to drown
Her voice still haunts you
And only with your laughter
Can you win.

You win the lasting laurels
With your laughter
It reaches like an arm
Before you sink
To win the solitary truth
You're after
You dare not ask this priestess
How to think.

I think of tears
I think of rain on shingles
I think of rain
I think of Roses Blue
I think of Rose
My heart begins to tremble
To see the place
She's lately gotten to.

Both Sides Now

Rows and floes and angel hair
And ice cream castles in the air
And feather canyons everywhere
I've looked at clouds that way
But now, they only block the sun
They rain and snow on everyone
So many things I would have done
But clouds got in my way –
 I've looked at clouds
 From both sides now
 From up and down
 And still somehow
 It's cloud illusions, I recall
 I really don't know clouds
 At all.

Moons and Junes and ferris wheels
The dizzy, dancing way you feel
As every fairy tale comes real
I've looked at love that way
But now, its just another show
You leave 'em laughing when you go
And if you care don't let them know
Don't give yourself away –
 I've looked at love
 From both sides now
 From give and take
 And still somehow
 It's loves' illusions I recall
 I really don't know love
 At all.

Tears and fears and feeling proud
To say "I love you" right out loud
Dreams and schemes
And circus crowds
I've looked at life that way
But now, old friends are acting strange
They shake their heads and say I've changed
Well something's lost
But something's gained
In living everyday –
 I've looked at life
 From both sides now
 From win and lose
 And still somehow
 It's lifes illusions I recall
 I really don't know life
 At all.

The Last Time I Saw Richard

The last time I saw Richard
Was Detroit in '68.
He told me "All romantics
Meet this fate, someday —
Cynical and drunk
And boring someone
In some dark cafe.
You laugh," he said,
"Do you think you're immune?
Go look at your eyes
They're full of moon
You like roses and kisses
And pretty men
To tell you pretty lies —
Pretty lies
When're you going to realize
They're only pretty lies.

He put a quarter in the Wurlitzer
And he pushed three buttons
And the thing began to whir
And the barmaid came by
In fishnet stockings and a bowtie
She said "Drink up now
It's gettin' on time to close!"
"Richard, you haven't really changed" I said
"Only now you're just romanticising some pain you've had
You've got tombs in your eyes
But the songs you punched are dreamy
Listen
They sing of love so sweet
Love so sweet
When're you going to get back on your feet
Love so sweet

Richard got married to a figure skater
And he bought her a dishwasher
And a coffee perculator
He drinks at home now most nights
With the T.V. on
And all the house lights left up bright
I'm going to blow this damn candle out
I don't want no one coming over to my table
I've got nothing to talk to anybody about
All good dreamers pass this way someday
Hiding behind bottles
In dark café's
Dark café
Just a dark cacoon
Before I get my gorgeous wings
And fly away
Only a phase
These dark café days

Blue

Blue
Songs are like tattoos
You know I've been to sea before
Crown and anchor me
Or, let me sail away
Hey Blue,
 There is a song for you, too
Ink on a pin
Underneath the skin
An empty space
To fill
In

Well there're so many sinking
Now you've got to keep thinking
You can make it thru these waves
Acid, booze and ass
Needles, guns, and grass
Lots of laughs
Lots of laughs.

Everybody's saying
That hell's the hippest way to go
Well I don't think so
But I'm taking a look
Around it
Though —
Blue
 I love you

Blue
Here is a shell for you
Inside you'll hear a sigh
A foggy lullaby
There is your song from me.

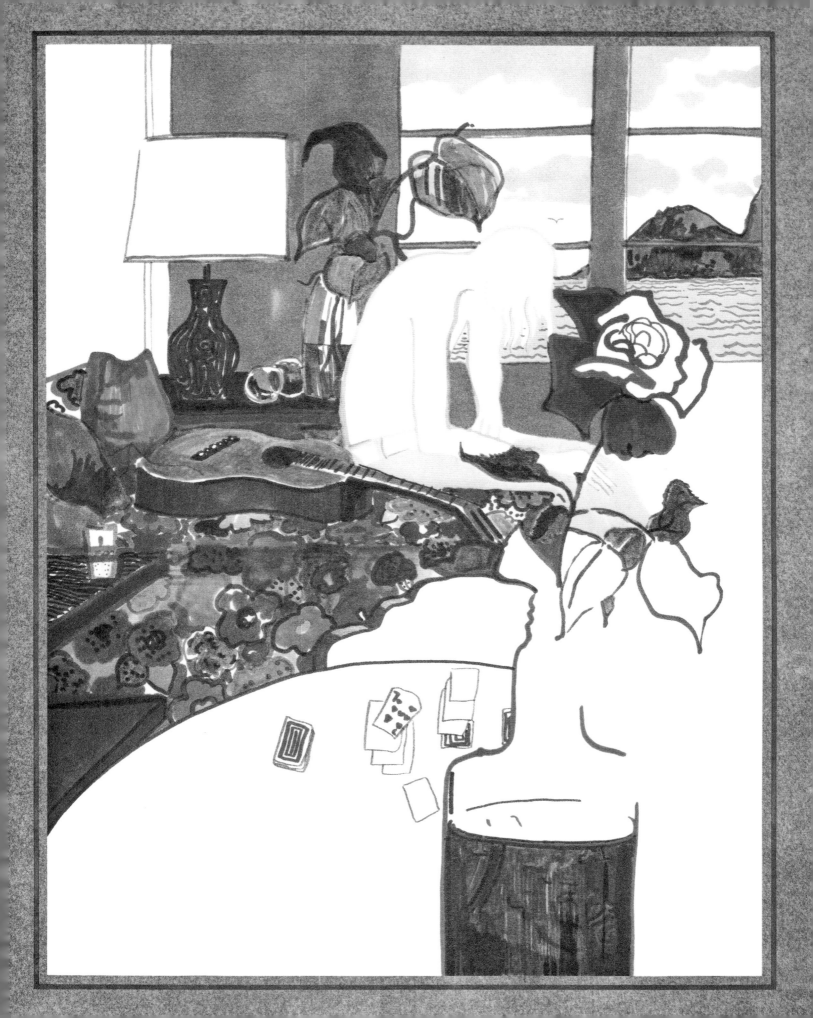

Song To a Seagull

Fly silly seabird
No dreams can possess you
No voices can blame you
For sun on your wings
My gentle relations
Have names they must call me
For loving the freedom
Of all flying things
 My dreams with the seagull fly
 Out of reach, out of cry.

I came to the city
And lived like old Crusoe
On a island of noise
In a cobblestone sea
And the beaches were concrete
And the stars payed a light-bill
And the blossoms hung false
On the store window trees
 My dreams with the seagull fly
 Out of reach, out of cry.

Out of the city
And down to the seaside
To sun on my shoulders
And wind in my hair
But sand castles crumble
And hunger is human
And humans are hungry
For worlds they can't share
 My dreams with the seagull fly
 Out of reach, out of cry.

I call to the seagull
Who dives to the waters
And catches his silver fine dinner
Alone
Crying "Where are the footprints
That danced on these beaches
And the hands that cast wishes
That sunk like a stone"
 My dreams with the seagulls fly
 Out of reach, out of cry.

 Cycle
What a beautiful story it is
Full of repeats, climaxes, and delays
When the shit comes down the turnpike
There's bound to be
A tree
Sprouting in it somewhere:
 The Cycle —
 The sprout
 Becomes the tree
 Becomes the oxygen
 Becomes the rain
 Becomes the river
 Becomes the sea
 And the meat
 Hunts other meat
 For a piece of it all
 And the earth
 Fragile in the universe
 Spins round and round
 In spirals
 And the meat
 Now
 Turn their technical teeth
 On her
 Their own living ground.

Sistobell Lane

Sisotobell lane
Noah is fixing the pump in the rain
He brings us no shame
We always knew
That he always knew
Up over the hill
Jovial neighbors come down when they will
With stories to tell
Sometimes they do
Sometimes they do—
We have a rocking chair
Sometimes we like to share

Eating muffin buns and berries
By the steamy kitchen window
Sometimes we do
Our tongues turn blue.

Sisotobell lane
Anywhere else now
Would seem very strange
The seasons are changing
Everyday
In every way
Sometimes it is spring
Sometimes it is not anything
A poet can sing
Sometimes we try
We always try —
We have a rocking chair
Somedays we sit and stare
At the woodlands
And the grasslands
And the badlands across the river
Sometimes we do
We like the view.

Sisotobell Lane
Go to the city
You'll come back again
To wade thru the grain
You always do
Some of us do
Come back to the stars
Sweet well water
And pickling jars
We'll lend you the car
We always do
Well, sometimes we do
We have a rocking chair
Someone is always there
Rocking rythms
While they're waiting
With the candle in the window
We always do
We wait for you .

Near the End of the Trip

Hands
Soiled
Wrinkled
Like old reptiles
They crawl into my pockets
To shed their skins!

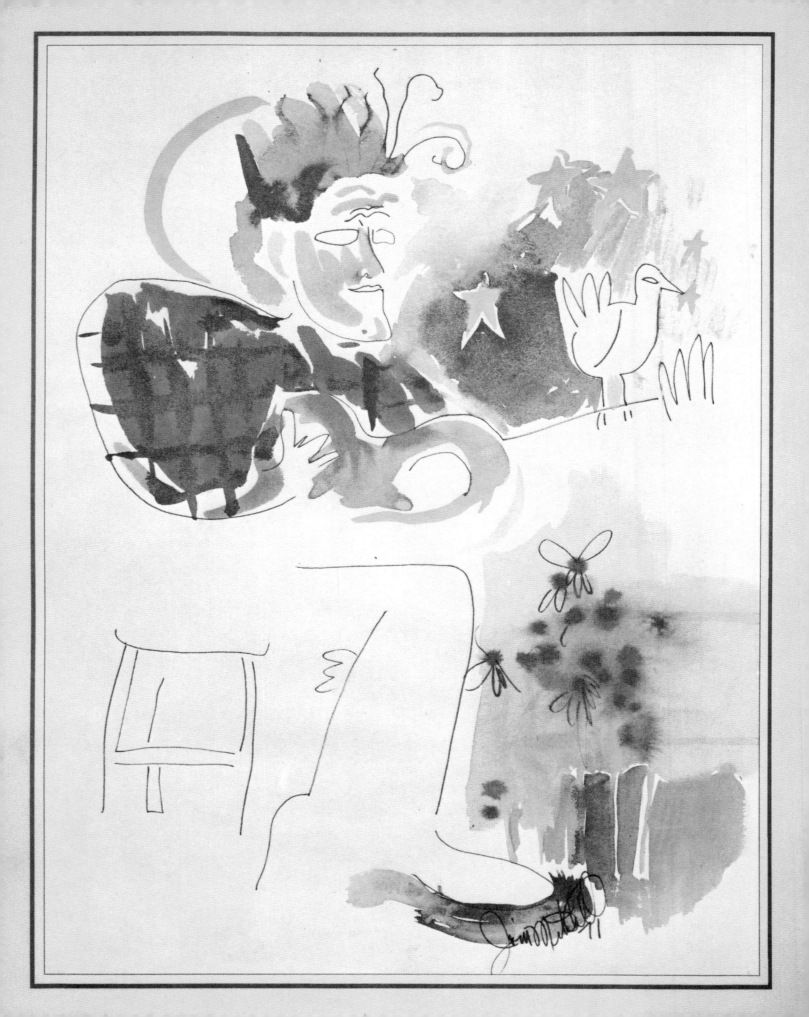

Let The Wind Carry Me

Papas faith is people
Mama she believes in cleaning
Papas faith is people
Mama's always cleaning
Papa brought home the sugar
Mama taught me the deeper meaning.

She don't like my kickpleat skirt
She don't like my eyelids painted green
She don't like me staying out late
In my high-heeled shoes
Living for that rock'n'roll dancing scene
Papa says "Leave the girl alone mother
She's looking like a movie queen."

Mama thinks she spoilt me
Papa's got the key, he sets me free
Mama thinks she spoilt me rotten
She blames herself
Papa — he blesses me
It's a rough road to travel
Mama let go now
It's always called me.

Sometimes I get that feeling
I want to raise a child up with somebody
I get that strong longing
Want to settle and raise a child
With somebody
But it passes like the summer
I'm a wild seed again then
Let the wind carry me.

The Carver

The carver comes in
Indian with thin whiskers
And a wife with strawberry hair
And an infant
With brand new teeth
Offers a beaded bag to me.
A strawberry voice
Softens the room
"She holds things out to you
But she takes them back."
I'm thinking — W.C. Mitchell.
"Little-Indian-Giver"
The man is tracing genetic visions
With magic markers on a pad —
"Maybe she's just showing it to you."
He speaks not looking up
From the mystery
Of green eyes [and lightning
flowing from his finger guides]
And [the grass
Smells sweet in the room.
I'm thinking, "It's hard to raise girls —
Harder in these times
Now that they're being liberated
If they didn't like their dolls
You know they're on their way."
She gets up
Takes the baby outside in the sun
And her blue velvet skirt
And her strawberry hair passing
Stirs the smoke around.

" The Haidas carve fine pipes
Animals all along the stem
Flowing together like smoke
A small bowl
And a fine hole right through -
Wonder what they smoked in those pipes
They had big boats
Travelled a long way
Maybe from South America
Or some islands
Where they grew cocaine leaves
Or something.
They grew their own smoke here
Tobacco the old ones say
But it wasn't tobacco
See this here drawing
I did this part on cocaine
It looks like Haida work
This snake coming up here looks Haida
They believe smoke goes to another world."
I'm thinking, "And it takes you
Through your own world
As an 'alien' - fearful and full of wonder."

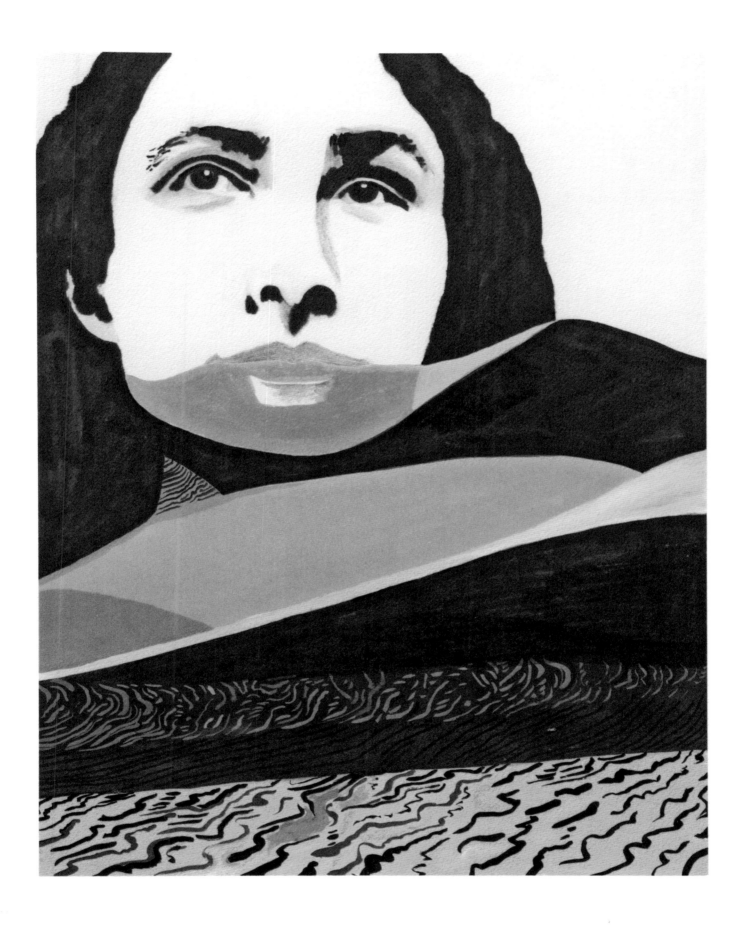

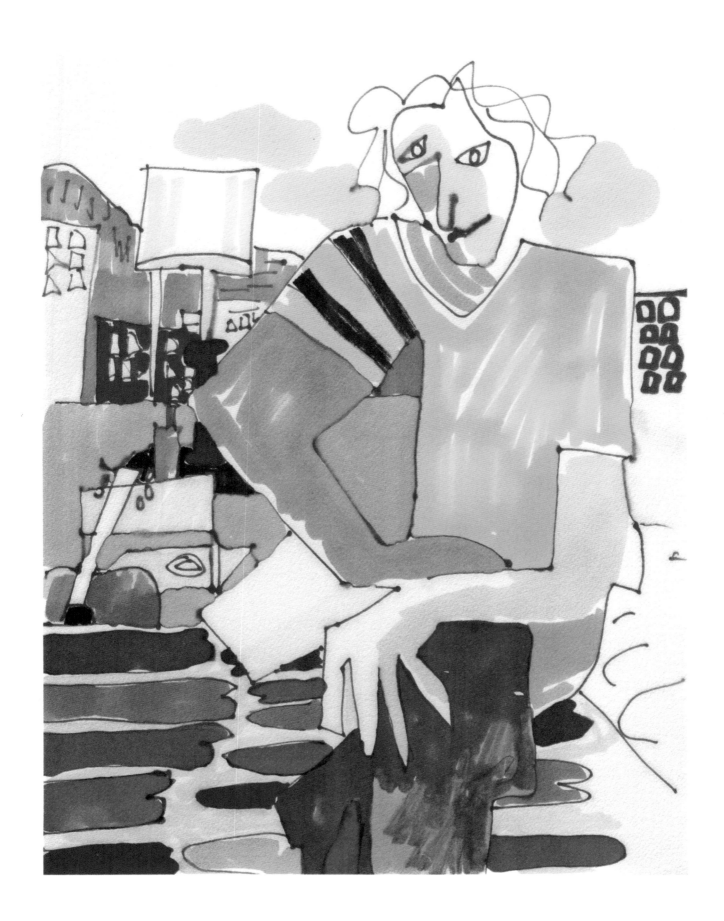

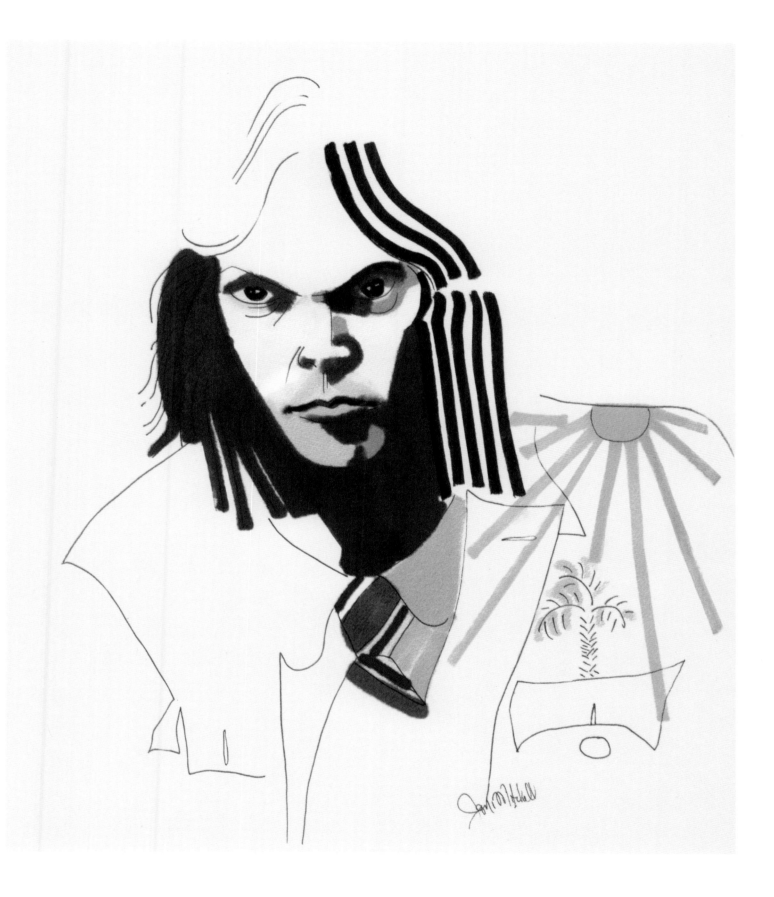

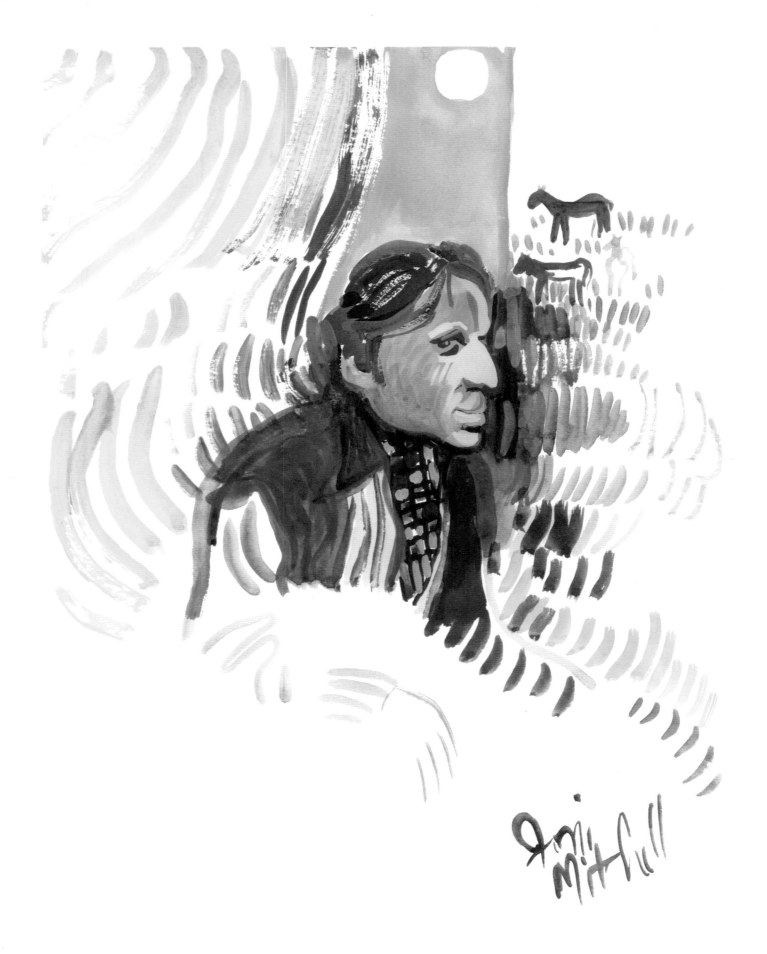

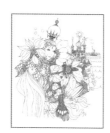 *Siquomb*

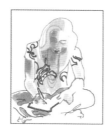 *Kassandra*

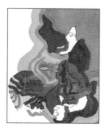 *Hunter*

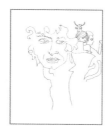 *Untitled*

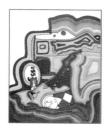 *Jane Lurie*

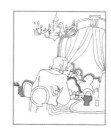 *Newport Dining Room*

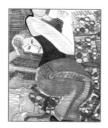 *Jane Lurie*

 Dallas Taylor

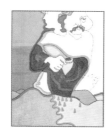 *Audience*

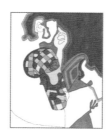 *Audience*

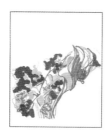 *Judy Collins*

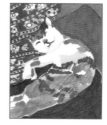 *Calico*

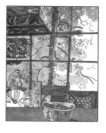 *Dining Room, Laurel Canyon*

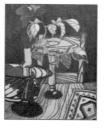 *Dining Room, Laurel Canyon*

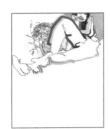 Fan on the Lawn

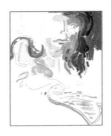 Abigail Hcness

 Graham Nash

 Dining Rocm, Newport Festival

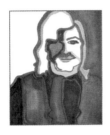 Graham Nash

 This Flight Tonight

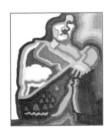 Graham Nash

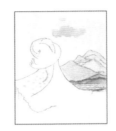 Court and Spark

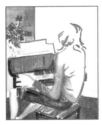 James Taylor

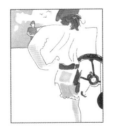 David Crosby, Panama Canal

 Fans, Wollman Rink, New York

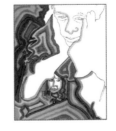 Untitled

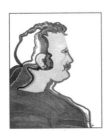 David Crosby

 Untitled

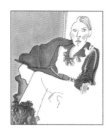

Self Portrait

Untitled

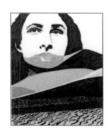

Georgia O'Keeffe

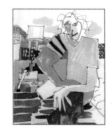

Murray McLauchlan

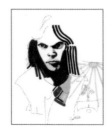

Neil Young

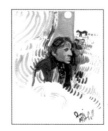

Elliot Roberts

hmhbooks.com

Library of Congress Cataloging-in-Publication Data is available.
ISBN 978-0-358-18172-9 (hardcover)
ISBN 978-0-358-30712-9 (special edition)
ISBN 978-0-358-33495-8 (special edition)